# Grafting Propriety

DANICA MAIER

# Grafting Propriety

## FROM STITCH TO THE DRAWN LINE

**black dog publishing**

london uk

# CONTENTS

# It's alright Ma
# I'm only Looking

JOHN PLOWMAN

Danica Maier is an artist whose practice is premised on the notion that what you see is not necessarily what you get. In a similar way this book, rather than providing a comprehensive survey of her practice, does offer us some clues for how to 'get' the work of Danica Maier. With an overarching interest in the relationship between her materials and exhibition site, she creates a duality that offers us the potential to generate a plurality of meanings.

To enter a Danica Maier exhibition, be it a gallery, a noticeboard or even an abandoned factory, is to enter a room, a room with a view. In some cases, we enter a room with many views, as the images of the Stitch & Peacock exhibition show. Her work challenges us to think about what it means to stand in a room with a view; in creating such a space she encourages us to think about how and where to direct our gaze. This provides the key to unlocking the many doors that begin to open up before us, revealing previously unknown perspectives. Time is of the essence here, not only in terms of our own temporal experience within the exhibition space, but also deeply embedded within the work we encounter. A fleeting glance, a swift walk-by will not suffice: we need to linger in the space and get to know the work. This allows us to walk towards it, to stand in front of it, empathise with its tactility and carefully peer into and beyond its materiality. Each of her works demand a long view followed by a close look paying attention to the details in order to unpick, in the metaphorical sense, the impropriety located within. Through her work Danica Maier examines and reflects on her interest in, and ongoing enquiry into, the domestic as the site of women's labour and the fruits of that labour. Her work has a particular focus on textiles and its histories, sites of production, decoration, form and function. Adopting a keen attention to detail, she encourages us to imagine the painstaking threading of a needle, followed by that first puncture in the fabric, the pulling of the thread up through the fabric before repeating the puncture and the movements of the needle as it travels methodically through time as the fruits of this labour become evident.

Danica Maier's work resides within the context of the gendered histories of labour in which "to work" is "to graft". But interestingly "graft" also means to procreate, creating new offspring off the host plant. In a similar way new meanings are created by Maier's seamless grafting of her work onto its site of exhibition, belying the complexities of the graft that has gone into the work's production. The visual characteristics of the stitch and its associated repetitive patterns have been simulated by the methodical accumulation of marks made by the pencil, a surrogate needle. The repetition and ordering of these pencil marks replicate those same labour intensive movements of the hand and eye of the embroiderer.

Maier tells us that repetition is also gendered, and foregrounds the seemingly trivial moments and repetitive tasks associated with the domestic and women's labour. The implication is that the everyday is important and relevant to our lived experience, individually and collectively. However it is not a question of simply aligning repetition and the production of the everyday with the mechanical processes first heralded by the industrial revolution, then finessed by Fordism before eventually leading to our current post-industrial state. In Danica Maier's work, the hand, and eye, are ever-present, indicating nostalgia for ways of making and doing that may seem at odds with our current condition, but in a sense are probably what we all hanker after.

When confronted with the work it is now we, the viewers, who have a task to undertake, to graft onto the work and its site of exhibition our individual responses. It is now our own eyes that we need to rely on to enable us to understand, or in a sense, 'unpick' what we see before us. Just as throughout history the eyes of the embroiderer have been intently focused on the area of the textile being worked. The task at hand is to move in closely, and look in and beyond what we see in front of us, and to think twice about our expectations of what we see and experience around us every day.

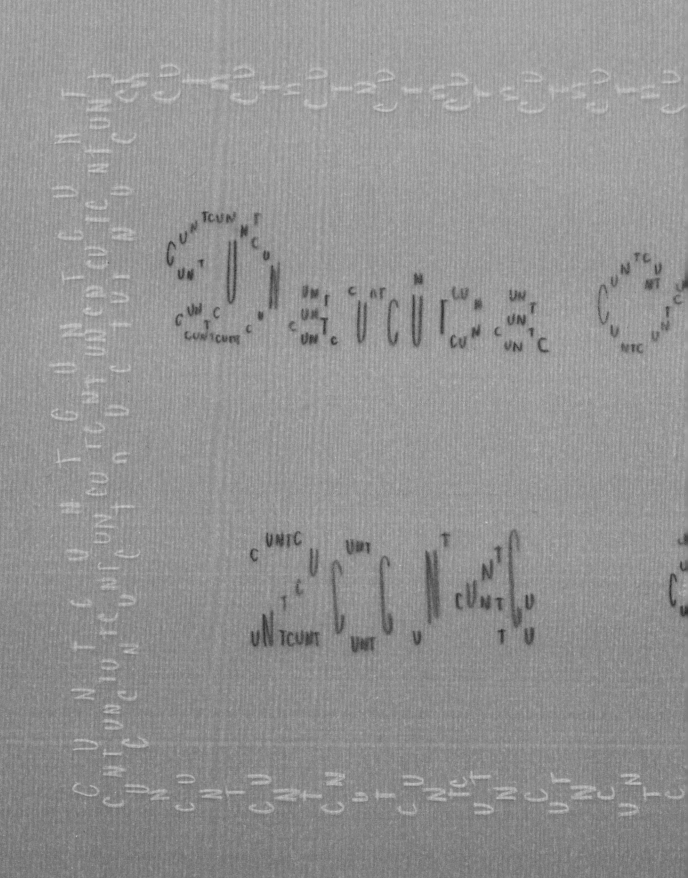

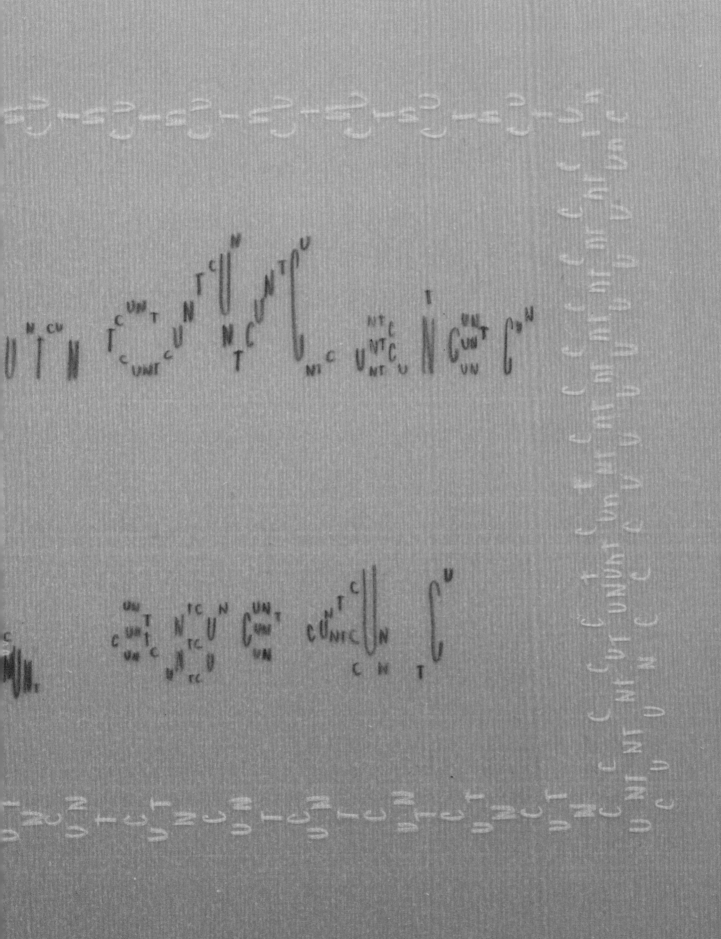

**Skein: DAM Cunt**
**2014**
23 x 15.5 cm, pencil drawing on Mylar
mounted on aluminium

# Stitch & Peacock

*Stitch & Peacock* an exhibition at The Collection Museum, Lincolnshire, was comprised of four major works developed over a seven-month research residency within The Collection and Usher Gallery's textile archive: *Nest, Happy Hunting Ground, Skein* and *Flock.* Maier's work focused on samplers and a Jacobean crewel embroidered bedspread, all objects that are rarely seen outside archival storage.  Maier produced a series of drawings that worked in conjunction with the archival pieces to produce an installation, yet the individual components—each drawing or historical object—can also stand alone.

# NEST

Comprised of three components, *Nest*'s focus is on a Jacobean crewel embroidery bedspread that is largely inaccessible to the general public. Maier's main interests in the bedspread are focused on: the double/repeated 'tree of life' motif; the repetition of similar shapes in each repeated 'tree of life', such as leaves and birds that have subtly different details; and the way the whole bedspread motif can extend in a repeated pattern, matching up with itself from both bottom to top and side to side, as found in a wallpaper repeat. As a way of hosting the Jacobean work, Maier created a repeating wall painting to draw the viewer into the gallery and towards the bedspread. On closer inspection however, this huge wall piece also reveals hidden depths and details of its own.

opposite
**Jacobean Bedspread (detail)**

following page
**Nest**
2014
5 x 10 mt, wall painting, Jacobean Bedspread,
drawing on Mylar
The Collection Museum, Lincoln

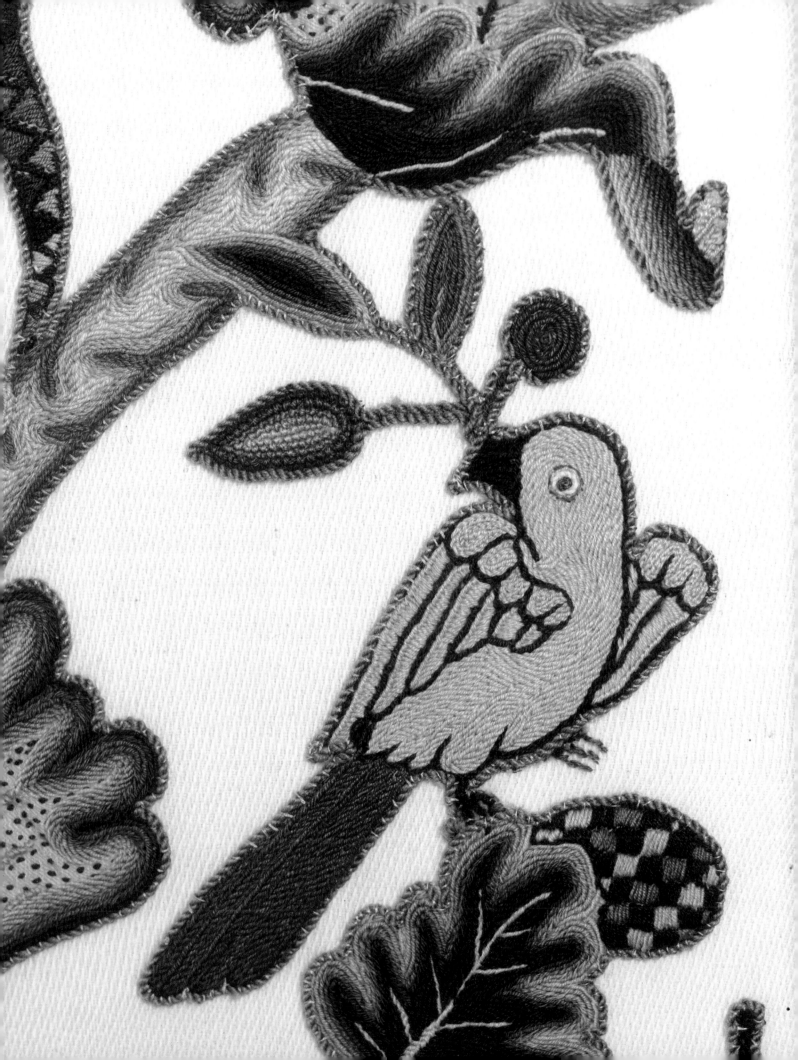

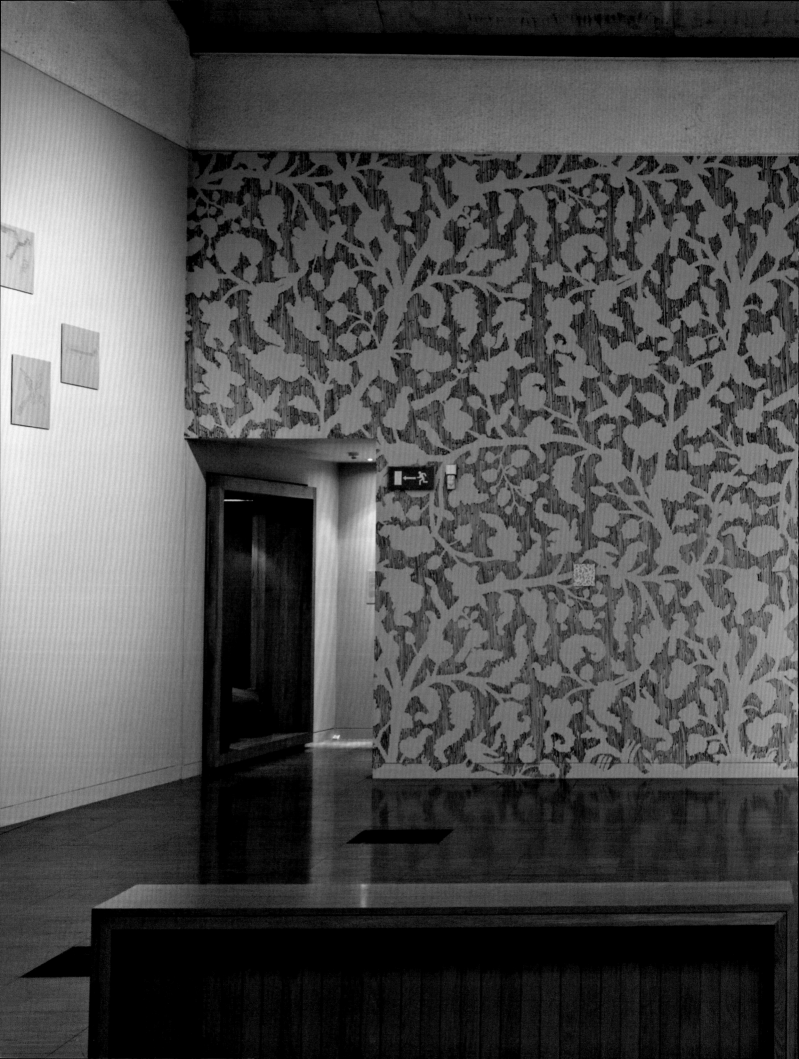

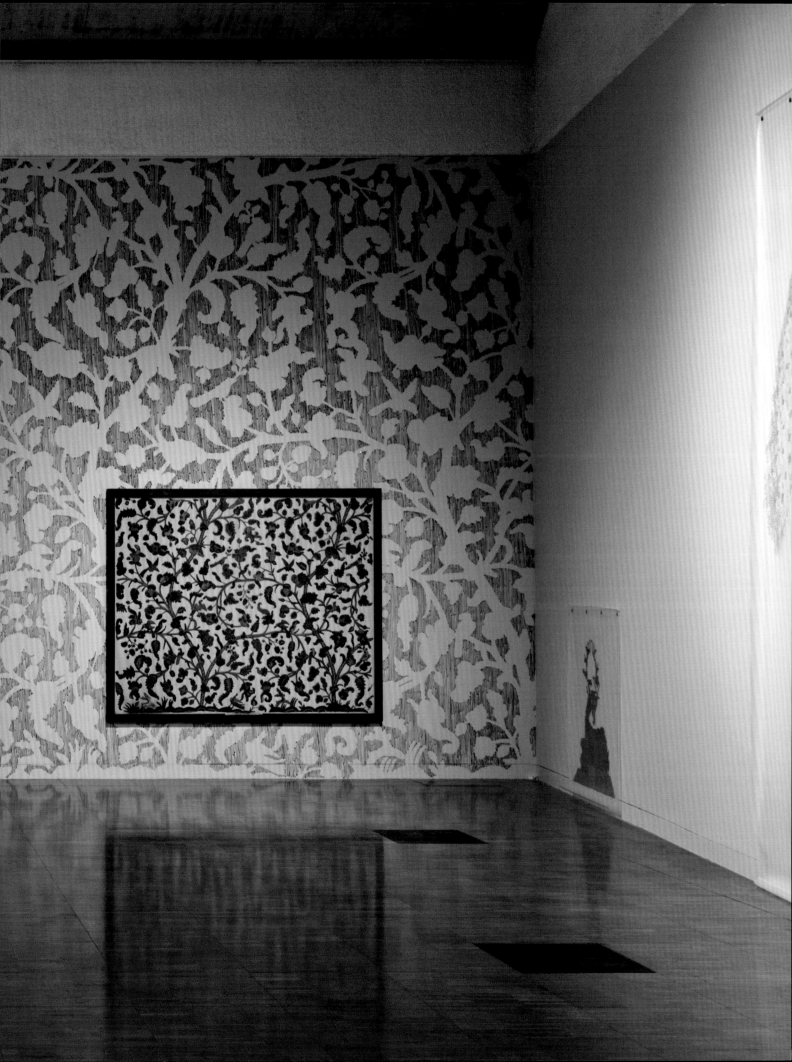

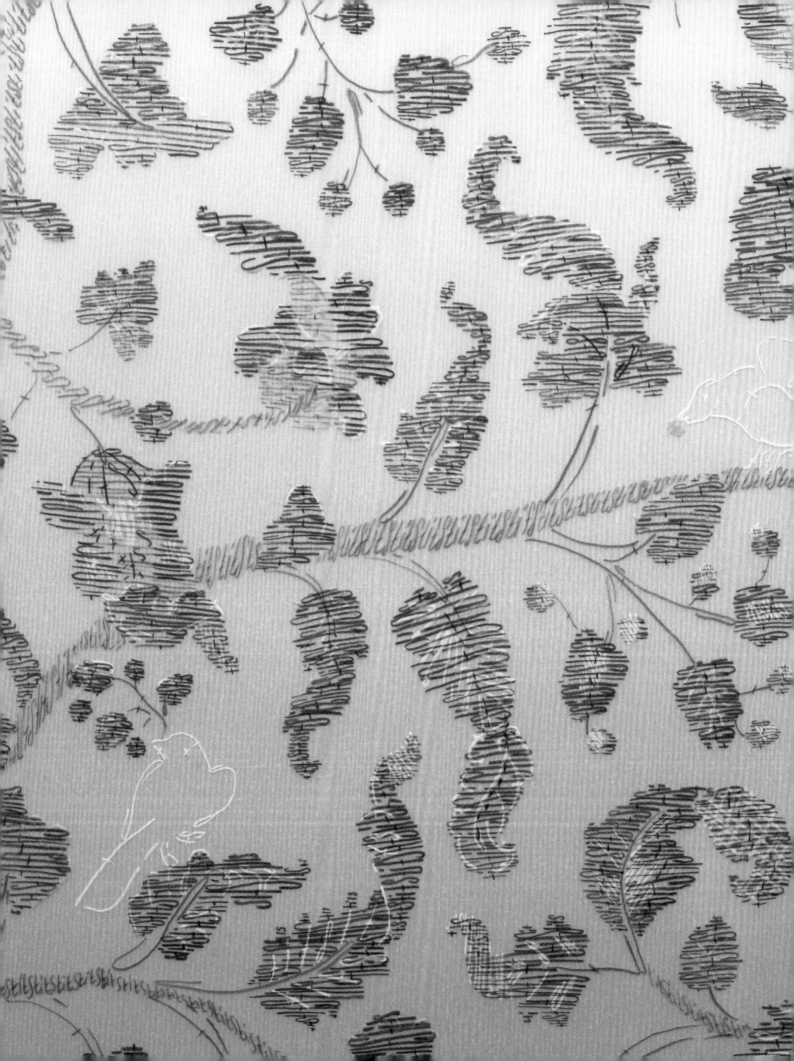

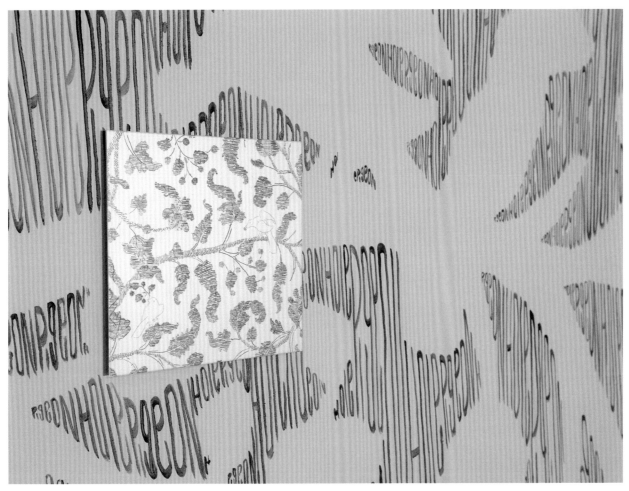

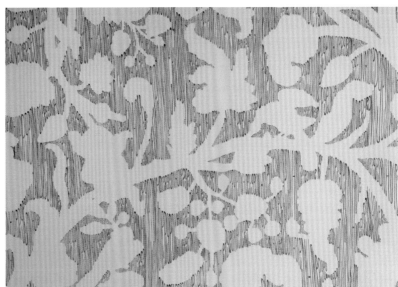

opposite
**Nest: Blue Tit**
2014
18 x 18 cm, pencil on Mylar mounted
on aluminium

top
**Nest: Blue Tit and Pigeon Hole**
2014
pencil on Mylar and wall painting
The Collection Museum

bottom
**Nest: Pigeon Hole (detail)**
2014
wall painting
The Collection Museum

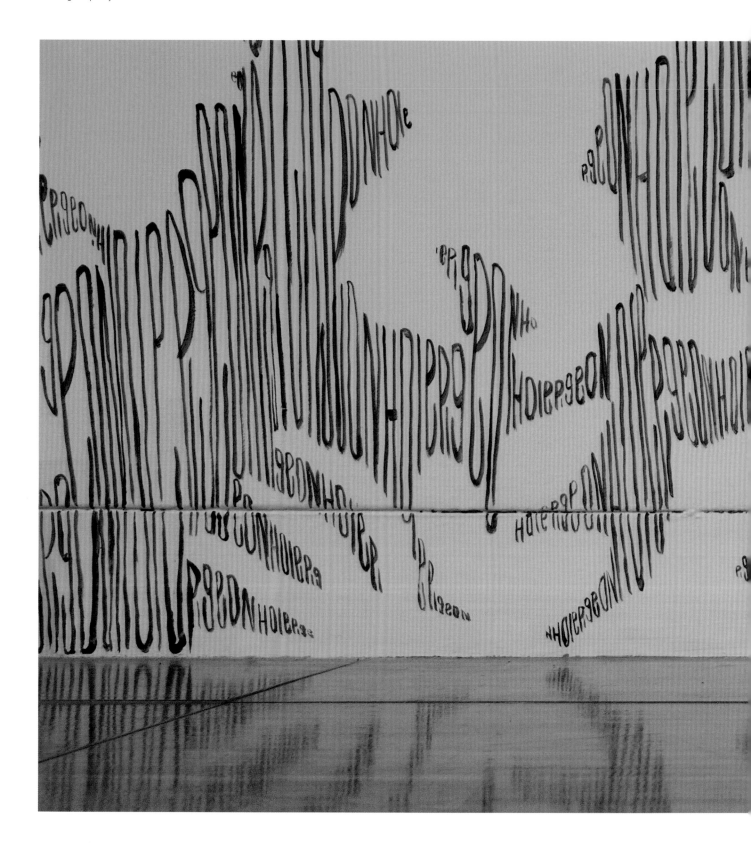

**Pigeon Hole (detail)**
2014
wall painting
The Collection Museum, Lincoln

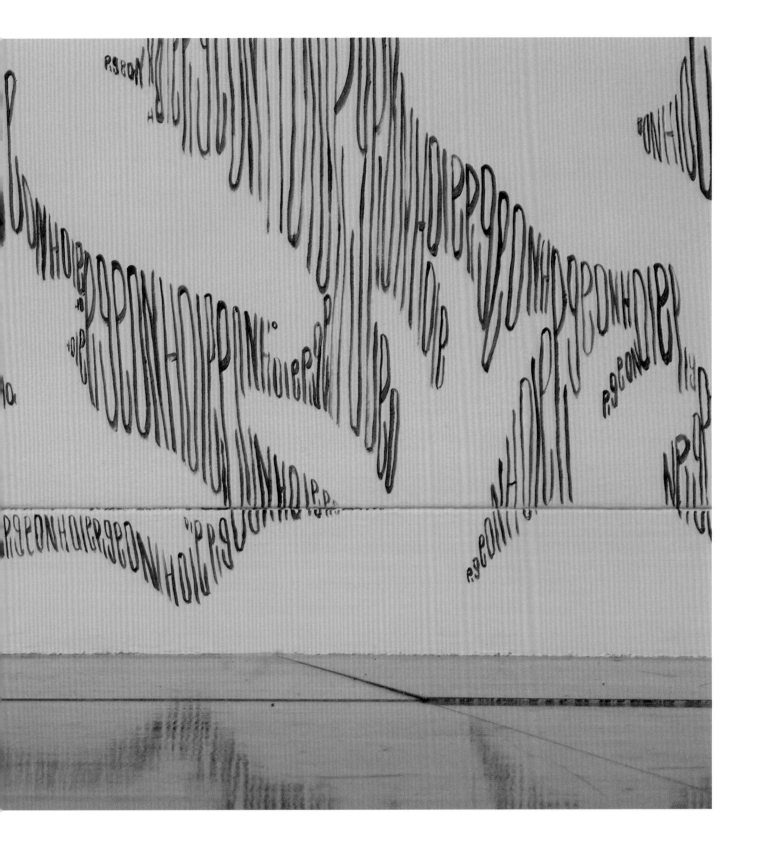

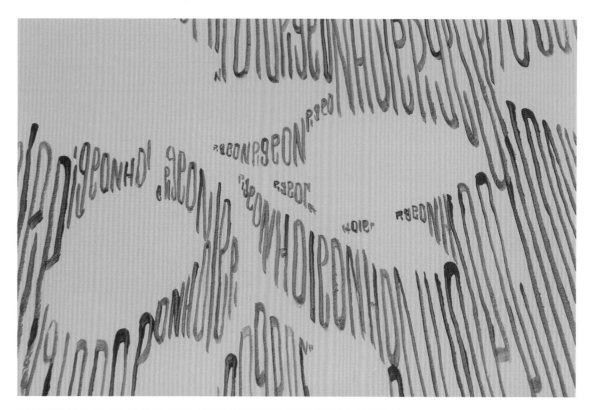

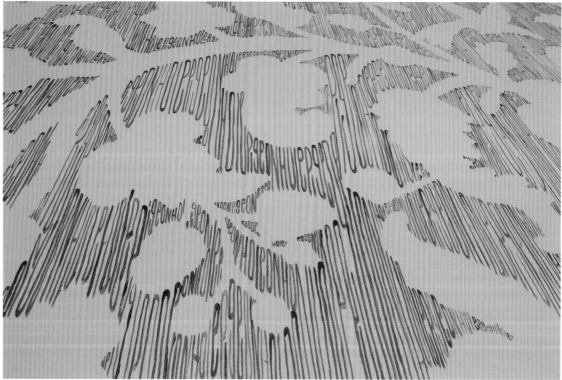

top and bottom
**Pigeon Hole (detail)**
2014
wall painting
The Collection Museum, Lincoln

opposite
**Pigeon Hole (detail)**
2014
Jacobean Bedspread
and wall painting
The Collection Museum, Lincoln

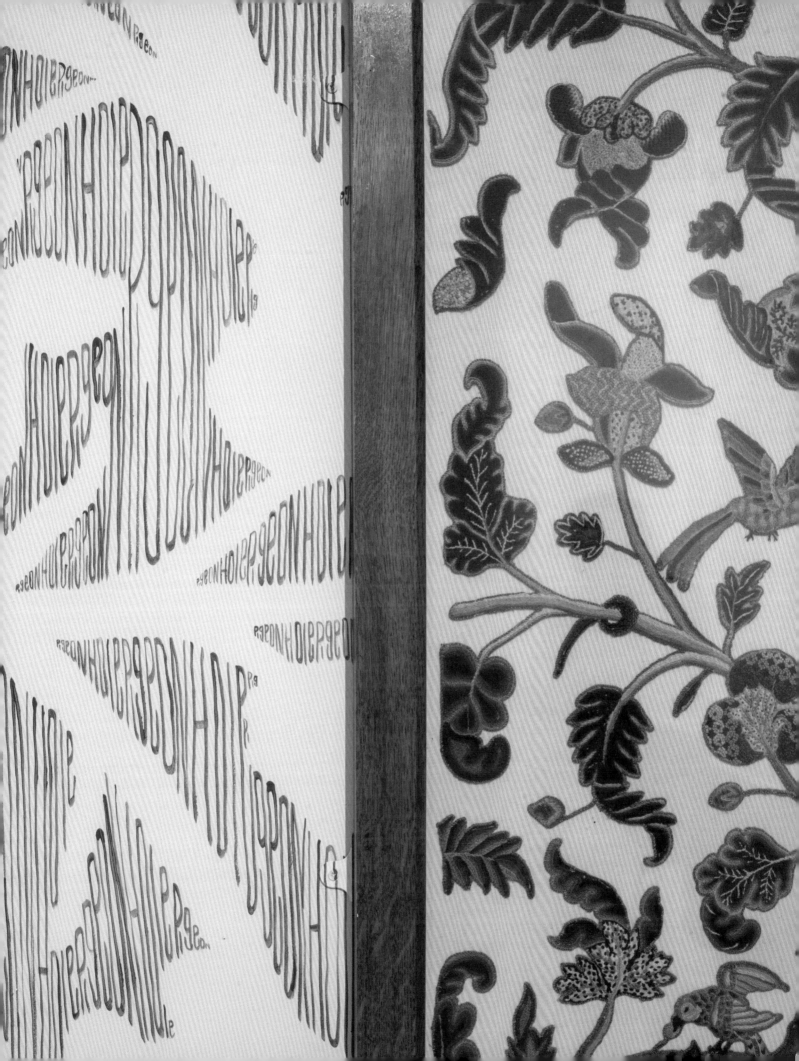

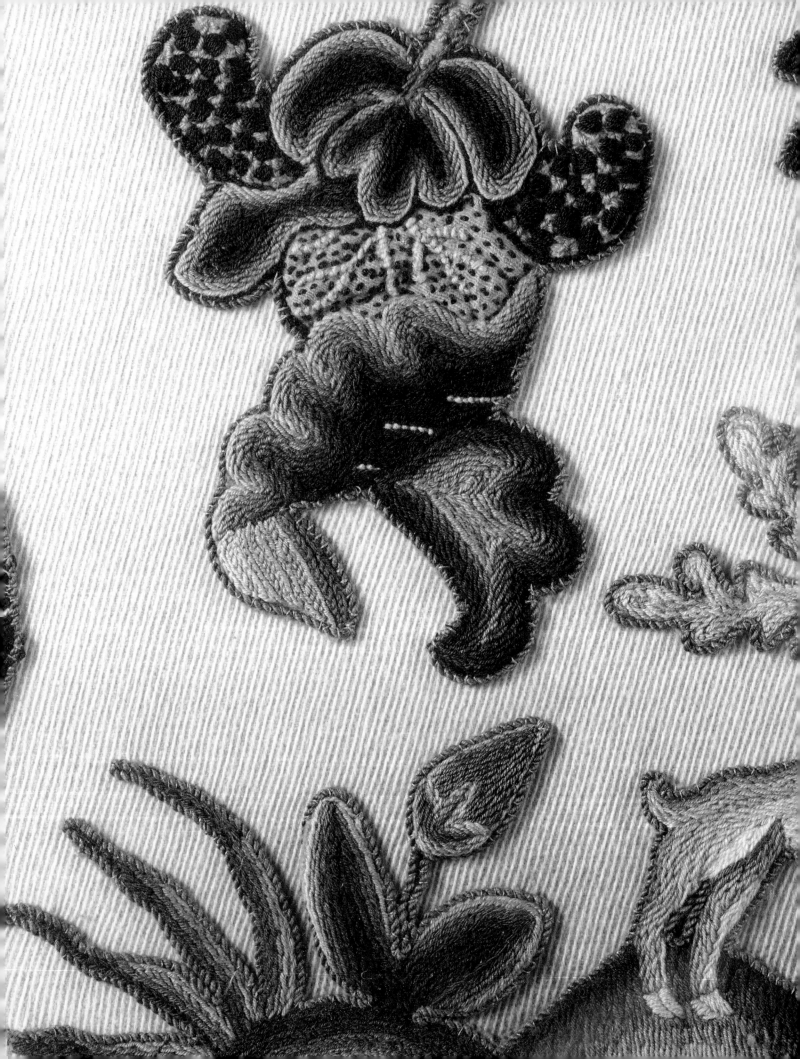

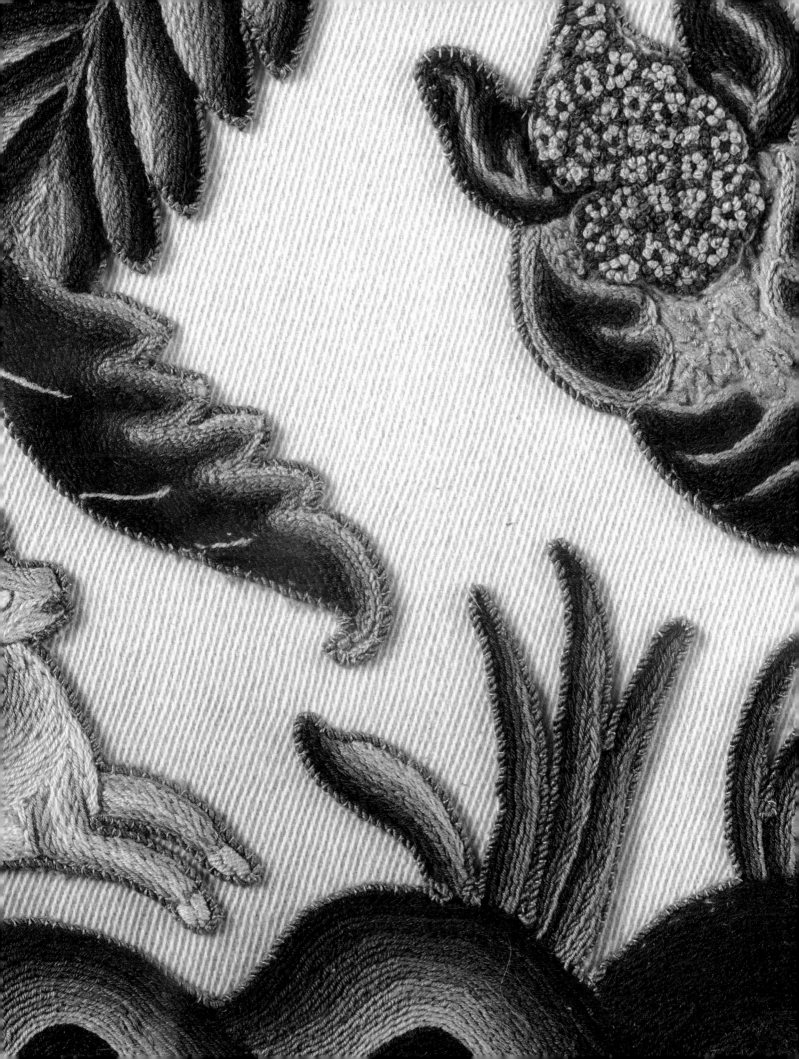

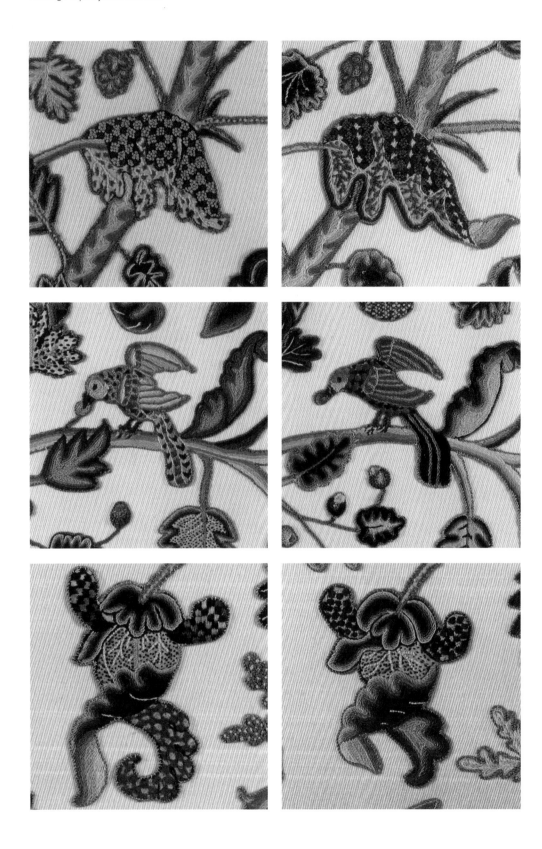

previous page and from top to bottom
**Jacobean Bedspread (detail)**
Part of The Usher Gallery archive

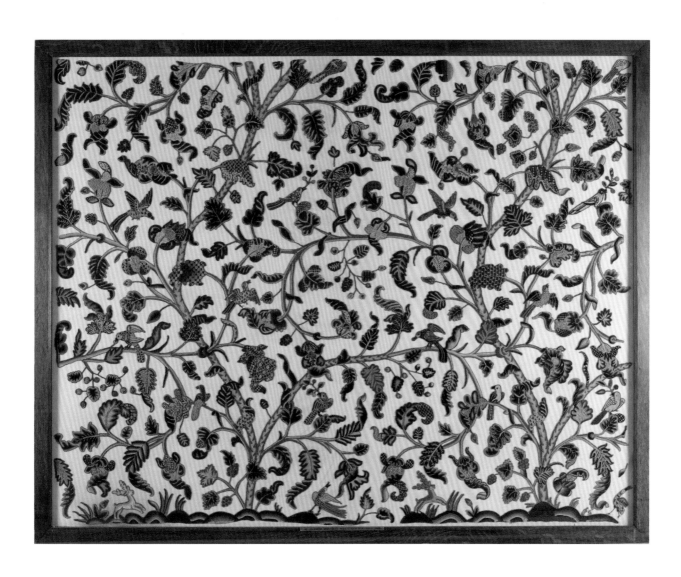

**Jacobean Bedspread** LCNUG:1927/30,
236 x 188 cm, a large bedspread of
Jacobean embroidery, ornately decorated
with merl stiching—intertwining branches
and foliage with birds, perched on and
picking fruit from the boughs. Heavily
restored in 1874.

# Sampler of Samplers Repeating Repeats Repeats

EMMA COCKER

The sampler: from *exemplum*. An example. In needlework, a test or task of sorts for demonstrating skill, variety of stitch practiced within a single frame. Over and over, again and again, stitch follows stitch yet each non-identical to the next in line. Incorporating a range of moves and methods—the sampler, site of both repetition and difference. Recognisable difference as running stitch folds over upon itself towards back, as chain stitch slips the lock of cross in unexpected loops and returns. Virtuous repetition of dutiful action momentarily breached by virtuoso twists and arabesques. Yet, even within the same species of stitch, variations in length and tension cannot wholly be erased. Even under pressure or duress the hand will not be made machine nor standard; embodied experience inescapably inflects every over and under of the thread. Every stitch records the lived instant of its own making, is woven through with the absent presence of she who was once there, now becoming dust. Sampler: from the French *essamplaire*—a model or role model, something to be copied through imitation. The sampler draws on an archive of existing patterns and templates, but invariably makes them her own. Act of copying a diagram or plan, yet rendering it physical, material. In the translation of the source book's page, the deviation of the line from drawn to thread, from flat to three-dimensions. Inevitable interpretation. Deficits. Surpluses. Embellishment. Excess. In the copy, repetition *and* difference. Here then, the sampler—used to instil duty, obedience, even conformity in the young girl, might also provoke reflection on the possibilities for divergence from design, or else from expectation. Busying idle hands can lead the mind to errant wander as much as stay on track. The difference, as the devil, is in the detail. So, pay attention to variations in the thread, to the anomalies and glitches in routine process for herein might lie nascent subversion, subtlest of dissidence.

The sampler: a test or task of sorts for demonstrating more than skill. For dwelling on the transformation as unruly thread is coaxed towards submission, duly brought to line. For dwelling on a good girl's virtues: patience, passivity, humility and gratitude. Or else every cut and drawn thread, a meditation on mortality, the brevity and fate of one's own life. Tender heart trembles as fingers move, infinite joy and endless woes, attend on every breath. Again and again, over and over, day after day, again and again, over and over, day after day [...] Day after day, self disciplined. Drill—a repetitive action used (sometimes punitively) to instil knowledge or habit, drawn from the old German term *rille:* to furrow, to cut a groove. The patterns shaped in the pull of thread are more than decorative. Lives too are hemmed and framed within the confines of the sampler's border edge; misspent minutes brought to lament. Yet, a controlled surface might also be flipped, revealing an underside of entangled knots and wayward threads, seething. Or notice where the thread has been unpicked and reworked, those perforations in the weave that tell of the once-drawn thread,

now removed. What unspeakable words and thoughts might have been woven, away from watchful eyes? In the meander of the thread, what digressions stitched and unstitched; written and retracted; versed, reversed? Daughters of Penelope—wily weaver of Ancient myth—weaving by day and unweaving by night, wilfully unravelling such that by morning the task might begin afresh. Unweaving and reweaving in act of quiet resistance, so as to thwart the terms of a situation from which there would seem to be no way out. Unweaving and reweaving the (narrative) thread or the direction of a life, so to stall or defer the inevitable ending, or to prevent against being boxed in, pigeonholed. The relentless repeat of again and again skips towards its affirmative variant, towards do and undo, from slavish adherence to the rule or routine towards a restless capacity for daily reimagining. The interminable chain of repetition switches; every stitch becomes a space for contemplating loopholes, those openings or apertures through which unwanted duty or obligation might yet be escaped, new lines of flight arise.

The sampler: she who samples; collector of examples. The authorised sampler is she of the archive or of the museum, entrusted to store or save fragments of the past from the ravages of time or accident. Curator—caretaker or rather she who takes care, protects. Etymologically related to the curate, curer of lost souls, shepherding the flock from damage or danger. Keeping the vulnerable or fragile safe from harm's grasp. Delicate samples gathered, classified, tucked away. Repeated or multiple acquisitions demonstrate commonalities and recurrent trends, whilst singular specimens and anomalies might have rarity, collector's value. Yet, what of the unauthorised sampler, she who gleans from the archive or factory floor, not to save from change but in order to transform? Propriety operates with appropriateness, conforming properly to the excepted standards. Propriety—designation of rightful ownership, of property and possession. To sample with impropriety is to appropriate, to borrow, even steal. The sampler draws on an archive of existing patterns and templates, but invariably makes them her own. In the act of copying, the deviation of the line from thread to drawn, to flat from three-dimensions. Inevitable interpretation. Deficits. Surpluses. Embellishment. Excess. In the copy, repetition *and* difference. Once a tactic of deconstruction or cool critique—of barbed pastiche, parodic emptying out—the practice of appropriation might also be performed with emancipatory intent, perhaps even with love. Reverent irreverence. Subversive re-enchantment. Fragment of a pattern, isolated and elaborated, given a life of its own. Migration of a singular motif—a bird in flight—let loose, liberated. Strange mutation of the detail that refuses to be scaled up, becoming formless, amorphous. Pixelated deformation. New hybrid forms born through hard graft. Unlikely conjunctions; edges shimmer, unstable. Further migration as the copy itself mutates from citation or quotation to version, then inversion, from

reversion to recursion. A copy of a copy, repeat of a repeat, of a repeat, of a repeat, repeat, repeatrepeatrepeatrepeatrepeatrepeatrepeatrepeatrepeat [...]

Repetition does not always clarify meaning since the more something is scrutinised the less it might become known. Familiarity can soon buck back upon itself towards estrangement. Repeating can evacuate meaning from language, rendering it nonsensical, absurd. Choose any word and say it aloud, over and over. How long before its sense collapses into only sound, its signification slips under waves of undulating rhythm? Or maybe opt to write the same word, time and time again. In time, the writing of a word drifts towards the drawing of a line; curve of letters spelt melt with pleasurable twist of the wrist, becoming serpentine. Language hinged between the event of reading and looking. Calligraphic: words born more of hand, than mind. Yet mindful must the hand that inscribes such words remain, for it is easy to lose focus, skilful repetition dissipating into careless scrawl. Every word might need the same degree of attention then. Performed like a mantra. Ritual repetition: babble of incantation. Words spelled out to rouse, invoke, for calling up or forth. With each repetition, increase in emphasis or amplification, heightened sensitivity. Multiple utterances of the same word can serve to intensify and dampen, numb and charge, sooth like a lullaby or else antagonise, grate and niggle. The same word can be used for different meaning; different words can be used to mean the same. Malkin. Mink. Civen. Cono. Poozel. Poes. Pigeonhole. Art of naming without the use of proper name, of substitution and exchange—euphemism: practice of saying without saying, or of saying one thing whilst meaning something else. Alternative meaning. Doubled meaning. Gulp. Plump. Rush. Clutch. Screw. Tittering. Trembling. Different words, same meaning for the novice, she who can only discern the flock, not the specificity of species within; for the twitcher unable to differentiate between chattering and bellowing, commotion and lamentation, deceit and pride; slow to tell charm from scold, ascension from descent, congregation from conspiracy, exaltation from murder.

Whilst repetition can homogenise, flattening and eroding detail, repeated engagement with a given subject can also sharpen one's focus or attention, nurturing a more nuanced gaze. For the practiced eye, the sighted flock challenges the finding of the right collective noun, discerning difference within what at first glance might seem indistinguishable. A flock. A fleet. A flight. Or a dissimulation—strange synonym it would seem for reflecting upon gathered birds on wing. Dissimulation—the act of feigning, of concealing one's capacity or identity through disguise; omission of facts or detail to gain advantage. Like the predator pretending to be harmless, pretending to be prey. Playing passive. Playing dead. There are creatures that have learnt to mimic fauna,

fallen leaf or inanimate rock. Camouflaged against their surrounds, they bide their time, until the time to bite. Others have evolved to imitate the seductive call of their own prey's mate, luring them unbeknownst to risk or danger. So too might subversion be concealed within the meekest stitch, filigree patterns used to dazzle, obfuscate the content within. Drawing the viewer closer, a little closer, still closer... until. Yet, in nature, the imperative to imitate evolves from a will to survive as much as to aggress, guile practiced deftly in defence, in lieu of force. Wily is the insect that pretends to be the leaf so as not to be eaten by the bird. Or maybe it is compelled, some say, curiously drawn by the call of surrounding space; edge of self liquescent, figure becoming ground, form becoming void, void becoming form becoming stitch, stitch becoming line becoming language. Edges blur too in the swerve and shimmer of starlings caught in dusk's ebbed light; singular speck of bird dissolved in wave of sheen and shadow, the collective murmuration irreducible to its individual parts. Or in the singular stitch surrendering itself to the service of pattern. Or the singular block of pattern repeated again and again, through duplication its original edges lost. Keen is the eye needed to spot the jog line, see each sole stitch, tell the insect from the leaf. Keener still the eye that can simultaneously discern both pattern *and* structure; stitch and image; mimic and the mimicked. Think of the illusion, how rare the seeing simultaneously of both the rabbit *and* the duck.

Doublethink—a capacity for simultaneously holding two seemingly contradictory beliefs or views. Double entendre—speech act holding two meanings, the indelicate second sense often in playful friction with the first. Double take— the glance that looks back, looks twice; the second seeing of something caught first only briefly, glimpsed in the corner of the eye. It is the look that takes the hint. Yet, the eyes often see what they want to see. Given even minimal prompt, mind too strives swiftly to draw connecting lines, is quick to fill the gaps when comprehension stumbles. Recognition is often first determined by knowing what one is looking for in advance. Repeated-cognition: the event of seeing again something previously seen or encountered; repetition of the already known and named. It can be difficult to see that which falls beyond the limits of prior experience or knowledge, far easier to conceive the seeing of that which isn't really there. Searching for resemblance, evidence of similarity, of similitude. Looking for a surface match. The lookalike resembles, mimicking the image of her double, taking another's appearance as her own. Appropriating a look, a likeness. The copy: alike yet inevitably unlike, always deficits or surpluses, embellishment or excess. Deeper worn is the familial resemblance, ingrained in the fabric of mind and muscle as much as on the surface scored. Species likeness. Genetic repetition. Certain family characteristics have survived through time, crossing centuries or seas, passed from one generation

to another. Genealogy—the study of descent, the tracing of lineage, an ancestral line or thread. Etymology—the lineage of language, linguistic evolution, its points of derivation and change. Some words mimic mnemonically the thing to which they refer; others tell a more convoluted narrative. Stories are passed from mother to daughter as much as DNA. Foundational stories. Formational stories. Repeated, repeated. Tradition. Ideology. Knowledge too, for how else might the migrating bird know to set in flight, when to return. Each individual life repeats the pattern of a pattern of a pattern of a pattern. Yet the relation between micro and macro is not self-similar, regressive. The individual draws on an archive of existing patterns and templates, but invariably makes them her own. Appropriating the past but to swerve it sideways: resisting whilst preserving, critiquing whilst caring, loving whilst at the same time letting go. Repeating without repeating. A version. Inversion. Reversion. Diversion. Mutation. Transformation. In the copy, repetition *and* difference.

# HAPPY HUNTING GROUND

*Happy Hunting Ground* plays with the scale of both stitch and pixel: an exquisite deer that is central to one sampler is transformed into a grotesque figure, curled up in a corner; a peacock is enlarged beyond its natural size and watches down upon all in the gallery; a falcon is virtually lost, eroded through faithful re-drawing of the cross stitch. Mylar hangs freely down to the floor, almost billowing like fabric. These birds and beasts, thus transformed, waver between solidity and transparency.

opposite
**Happy Hunting Ground: Cock (detail)**
**2014**
pencil drawing on Mylar

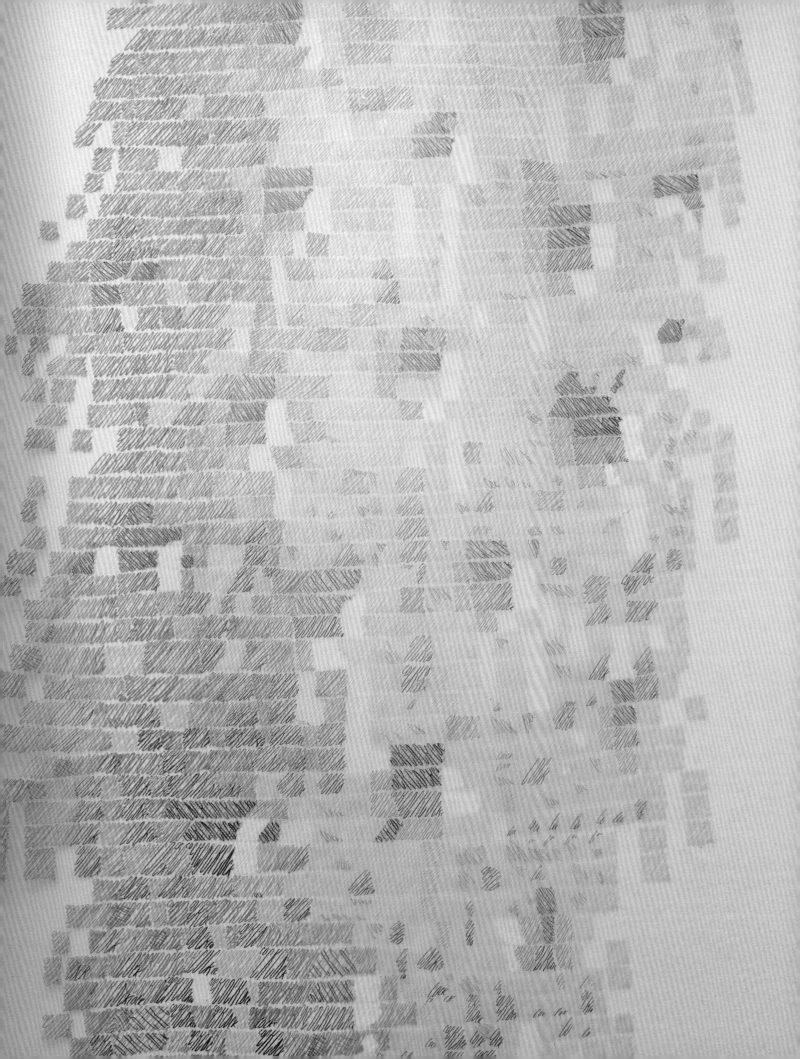

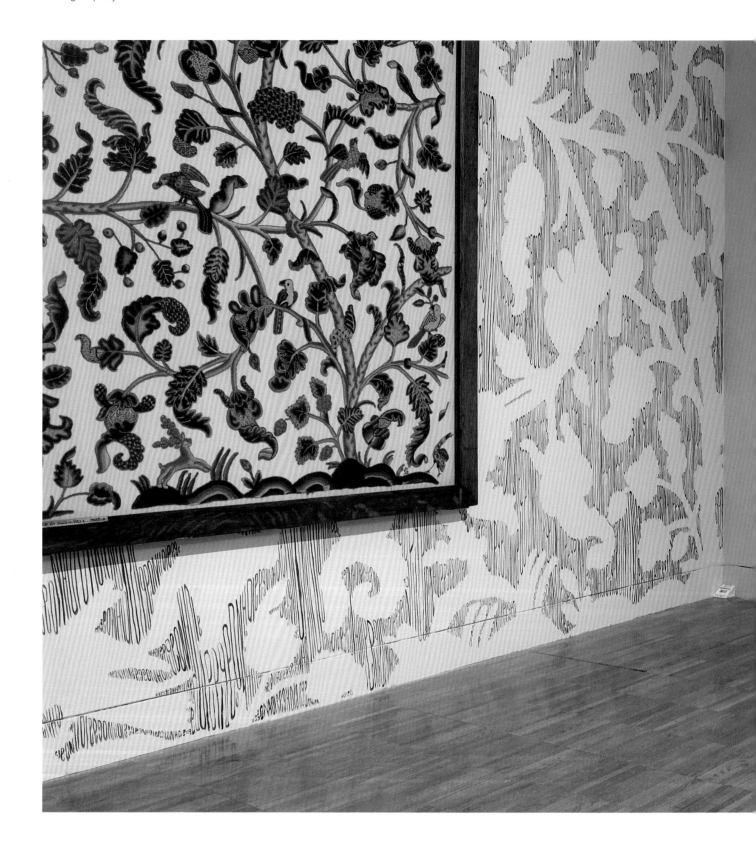

**Happy Hunting Ground: Stag**
2014
pencil drawing on Mylar
The Collection Museum, Lincoln

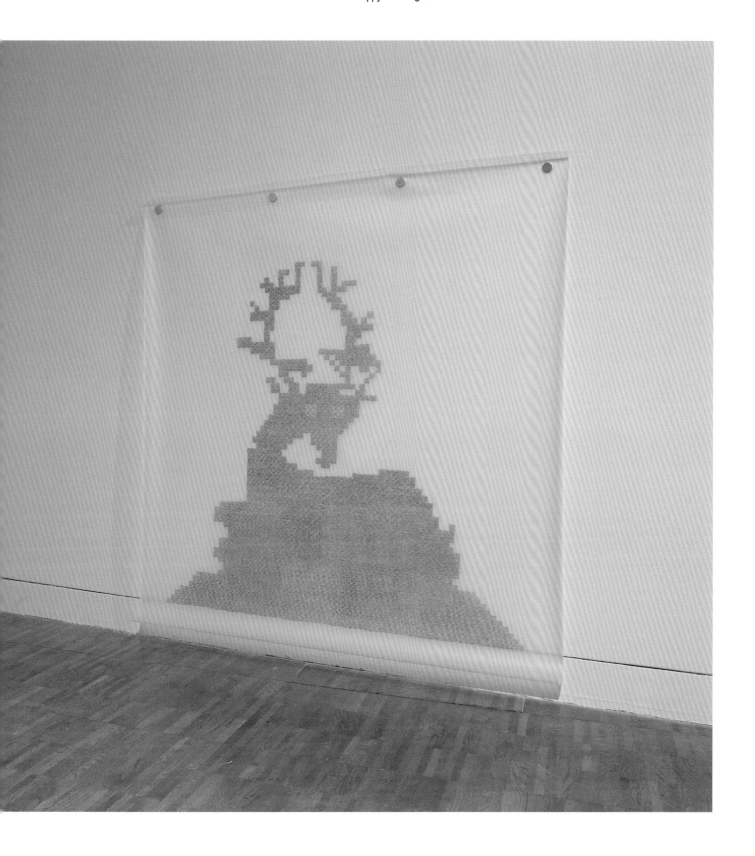

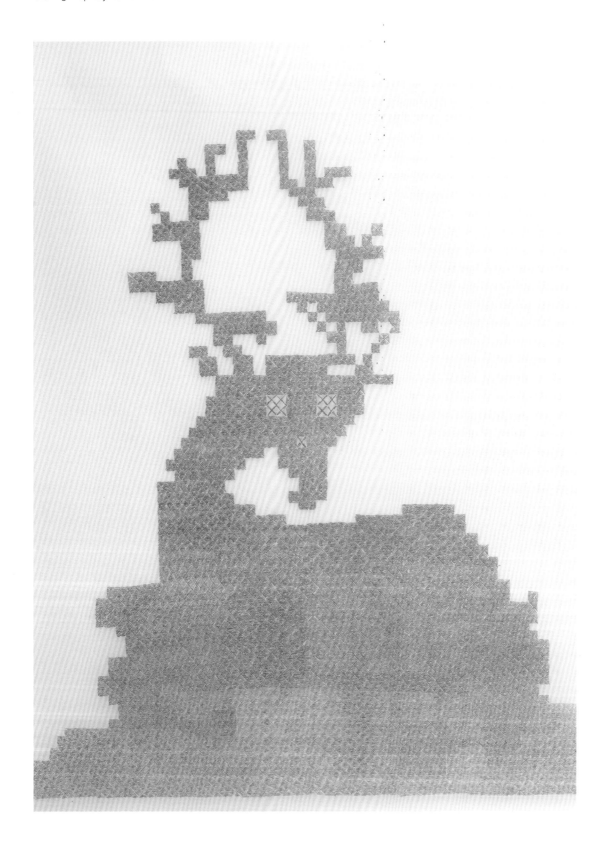

**Happy Hunting Ground: Stag, Cock and Tiercel**
2014
8.5 x 5 mt, pencil drawing on Mylar
The Collection Museum, Lincoln

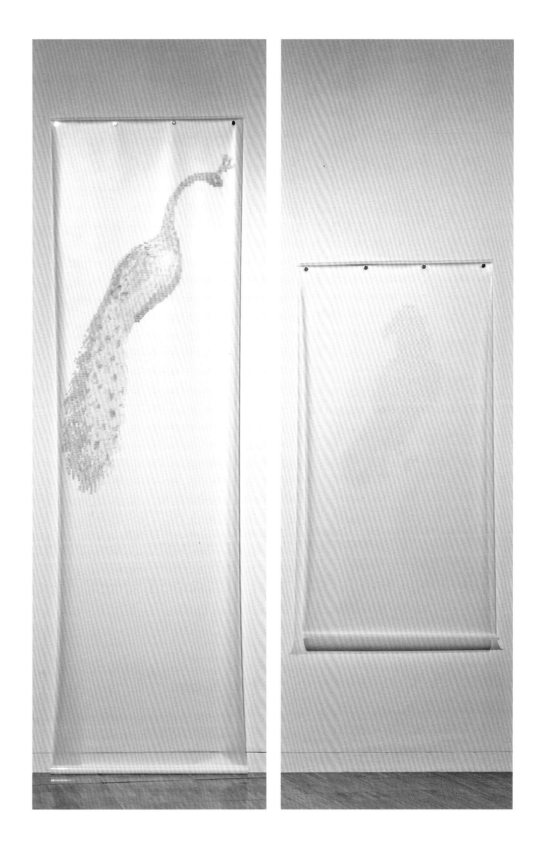

**Happy Hunting Ground: Stag (detail)**
2014
120 x 145 cm, pencil drawing on Mylar
The Collection Museum, Lincoln

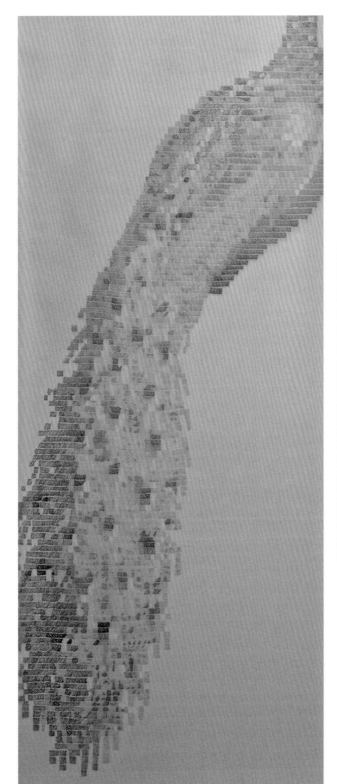

**Happy Hunting Ground: Cock (detail)**
2014
120 x 420 cm, pencil drawing on Mylar
The Collection Museum, Lincoln

**Happy Hunting Ground: Tiercel (detail)**
2014
120 x 245 cm, pencil drawing on Mylar
The Collection Museum, Lincoln

# SKEIN

*Skein* brings together Maier's drawings and historical samplers from the Usher Gallery's archive. Playing with ideas of the drawn line, thread and the stitched line, these drawings dissect image, method and ideas from the original source material. Working together as a single body and installed so as to reference archival storage racking systems, the drawings bring attention to, and resonate with, details found within the samplers they were shown amongst.

opposite
**Skein (detail showing Cono & Twat)**
**2014**
pencil drawing and historical samplers
The Collection Museum, Lincoln

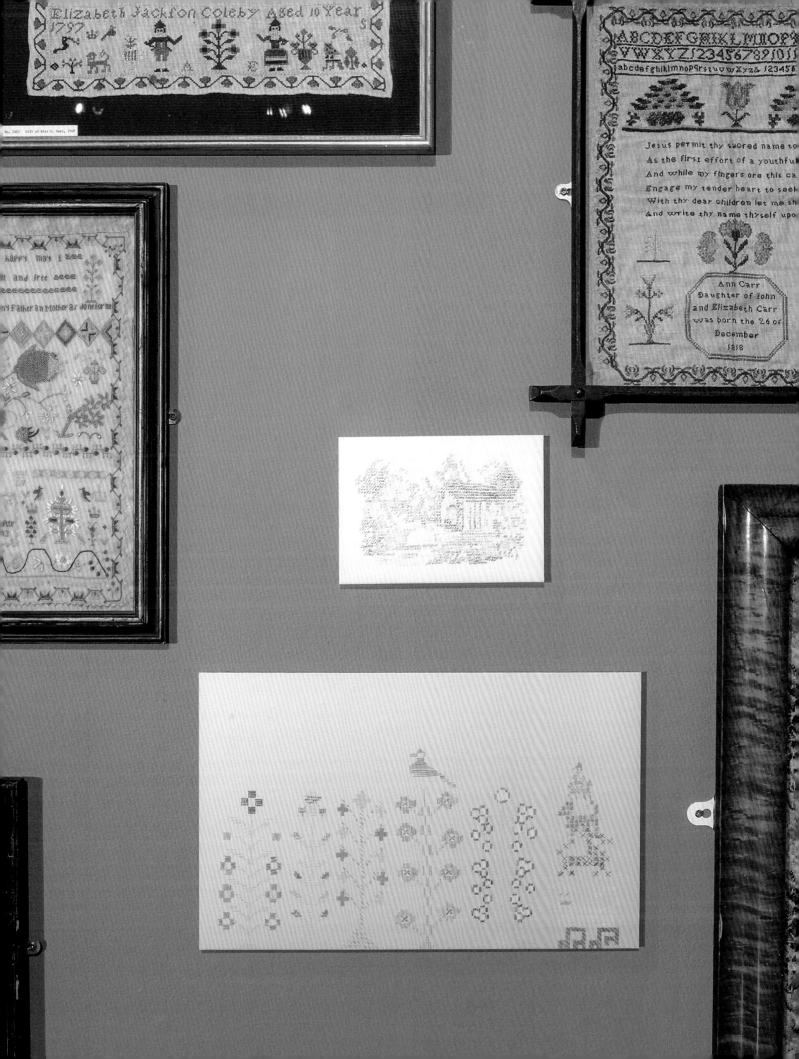

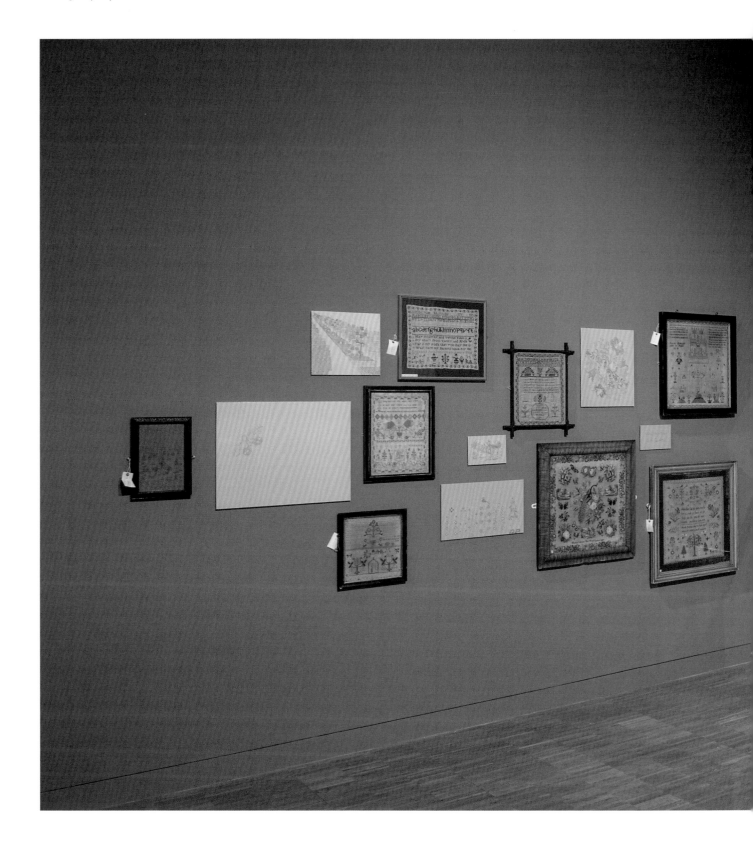

**Skein**
**2014**
6.5 x 2.5 mt, pencil drawing and historical samplers
The Collection Museum, Lincoln

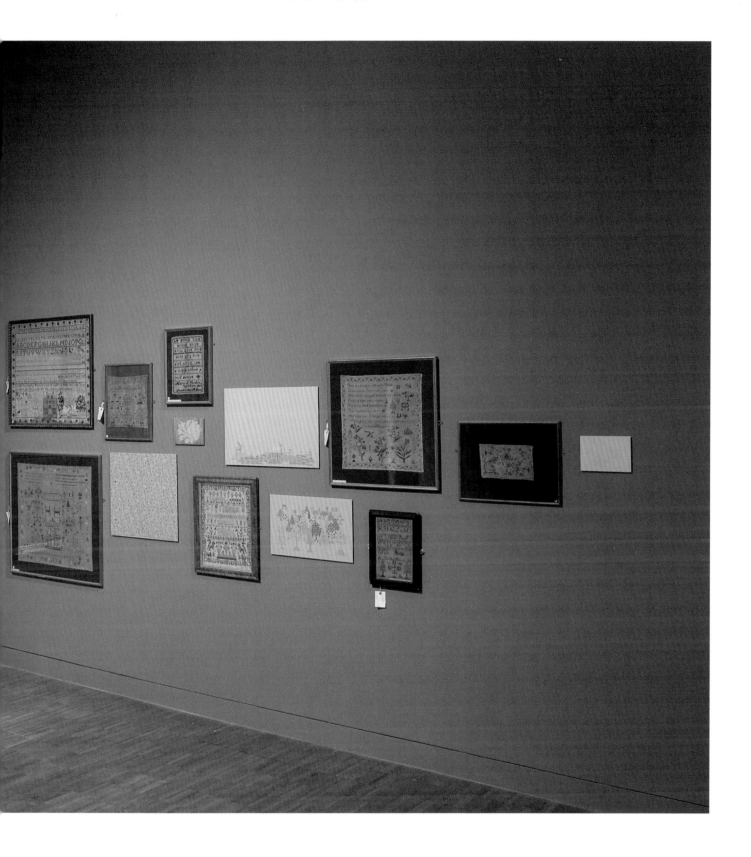

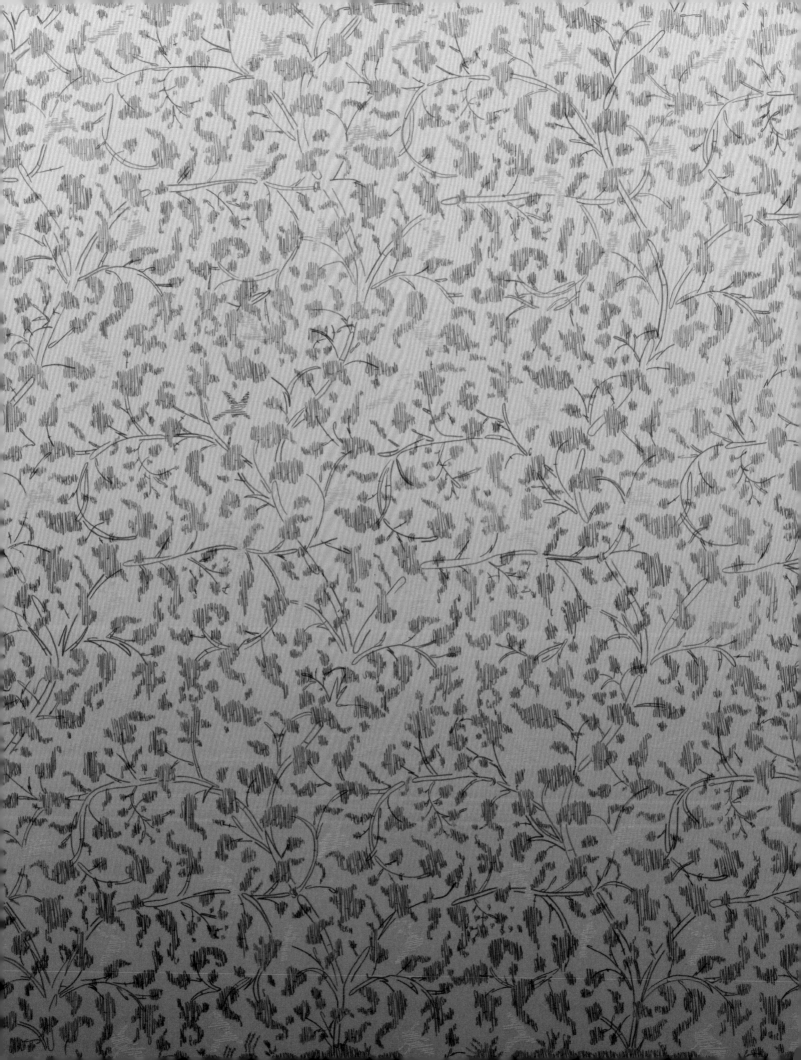

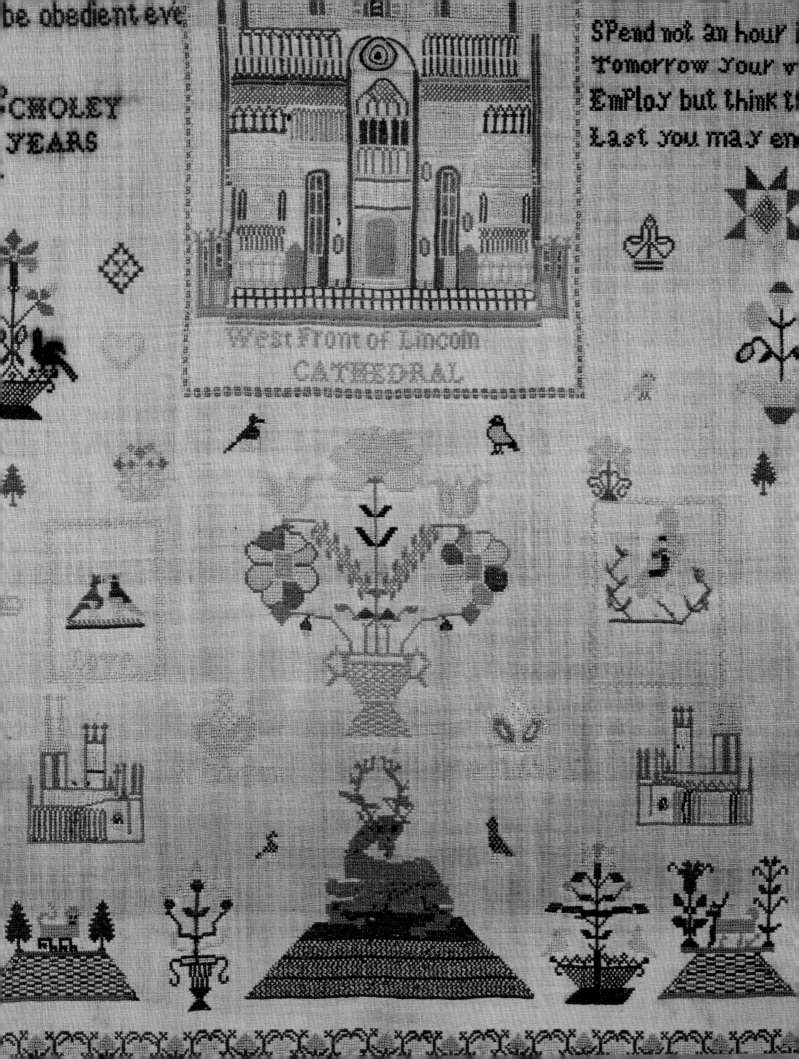

be obedient eve

CHOLEY
YEARS

SPend not an hour
Tomorrow Your
EmPloy but think t
Last you may en

West Front of Lincoln
CATHEDRAL

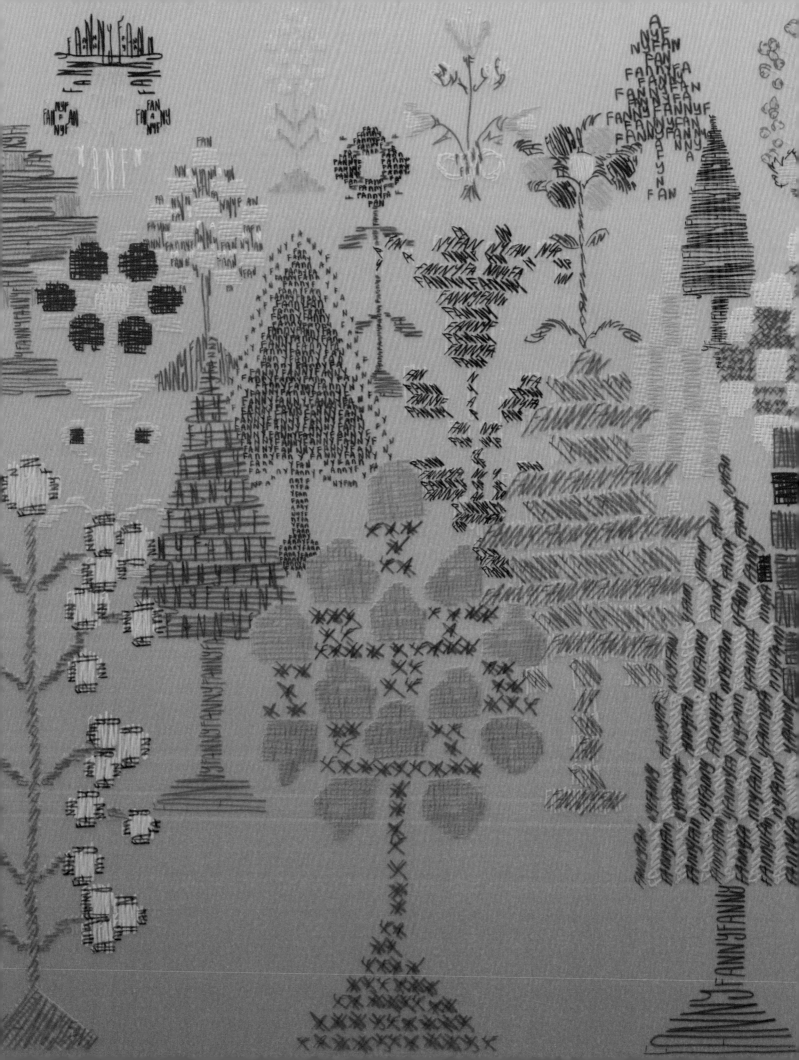

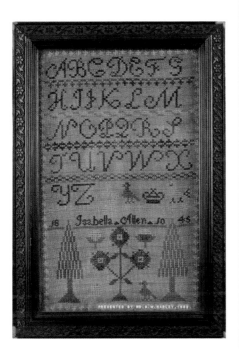

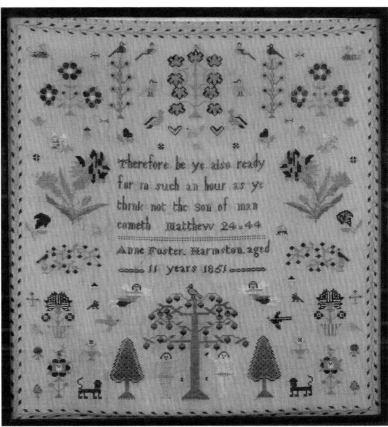

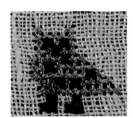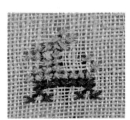

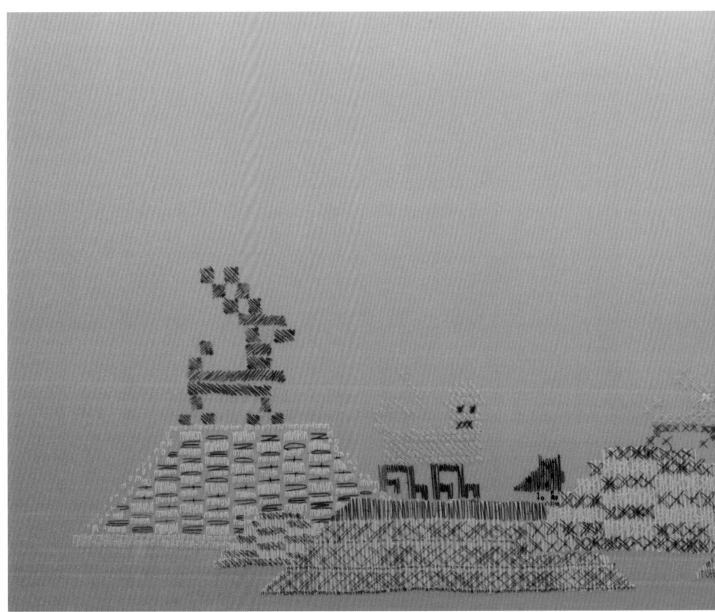

bottom
**Skein: Mutton (detail)**
**2014**
49 x 29.5 cm pencil drawing on Mylar
mounted on aluminium

top left to right
details from various historical samplers
from the Usher Collection Archive

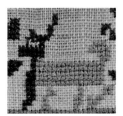

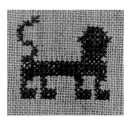

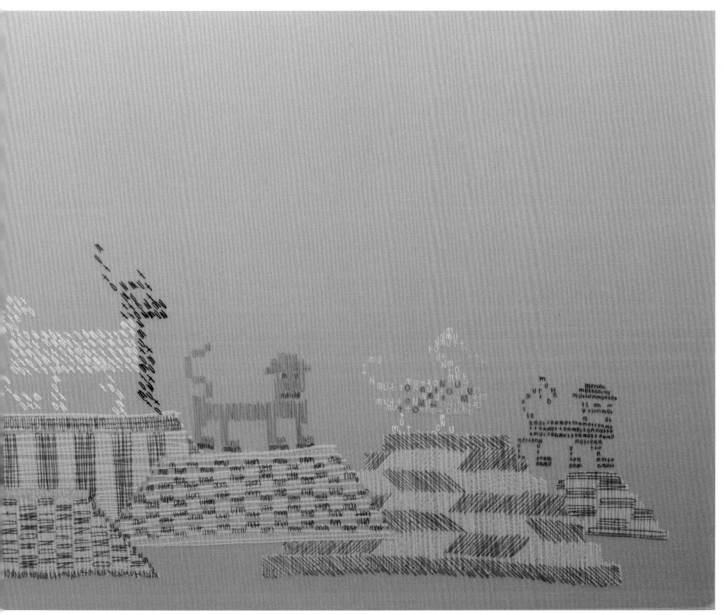

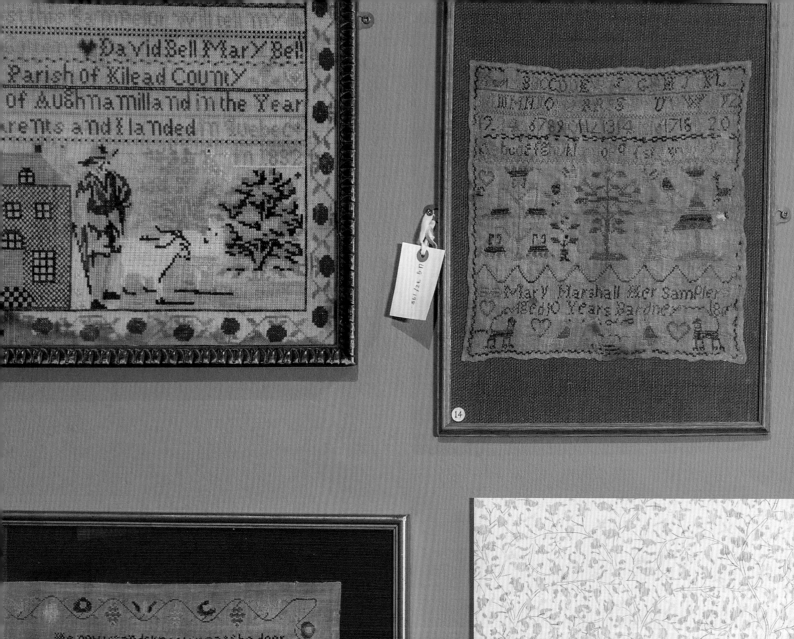

David Bell Mary Bell
Parish of Kilead COUNTY
of Aughna Milland in the Year
rents and Elanded

Mary Marshall Her Sampler
Aged 10 Years Gardner 18..

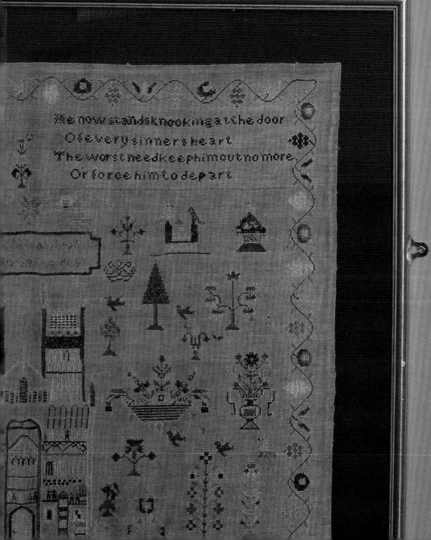

He now stands knocking at the door
Of every sinners heart
The worst need keep him out no more
Or force him to depart

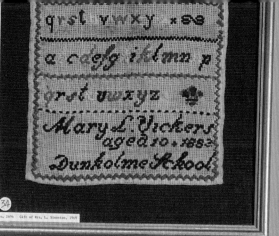

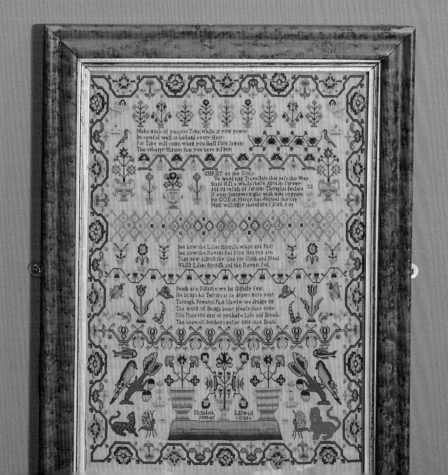

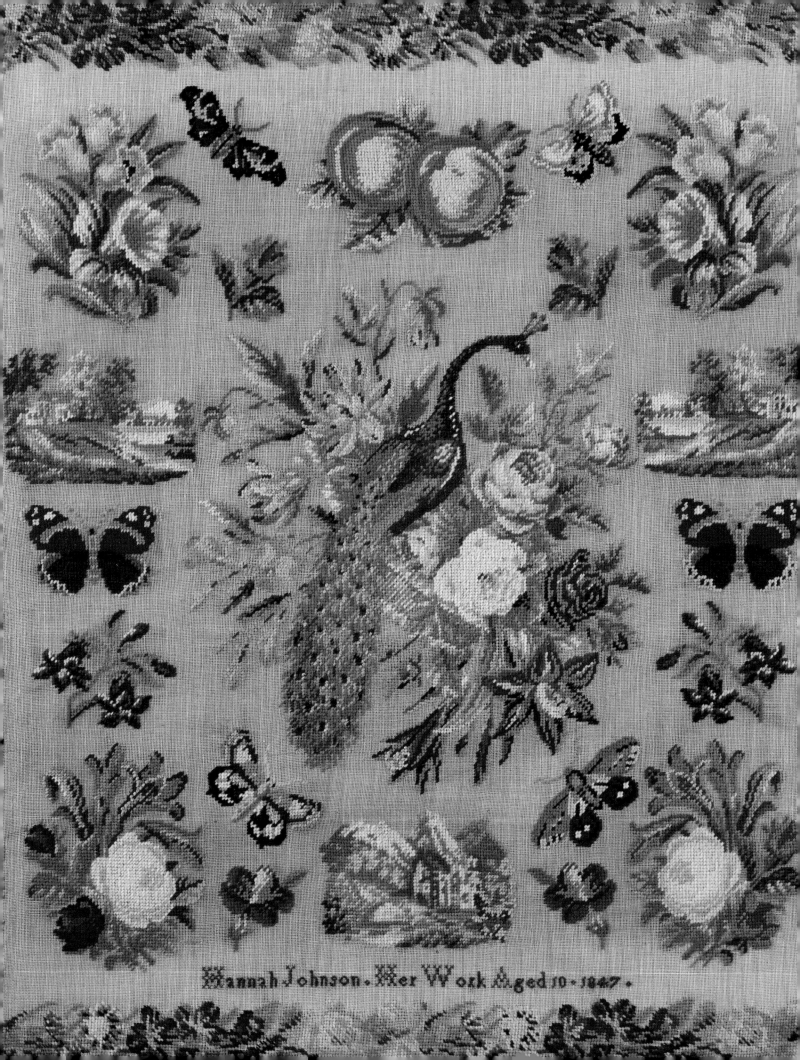

Hannah Johnson. Her Work Aged 10. 1847.

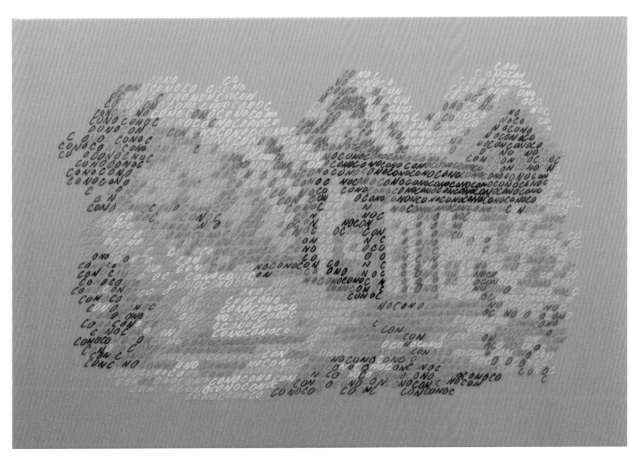

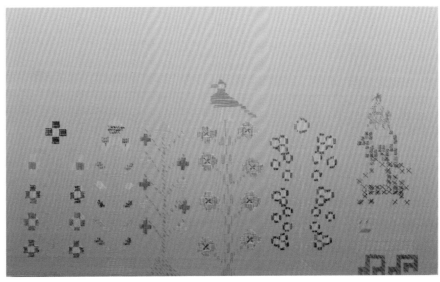

previous page
**Skein (detail showing Black Tit
and Snatchel)**
2014
pencil drawing and historical samplers

opposite
**Sampler**
1847
LCNUG:1927/2771, Historical Sampler,
Hannah Johnson
Part of The Usher Gallery archive

top
**Skein: Cono**
2014
24 x 15 cm, pencil drawing on Mylar
mounted on aluminium

bottom
**Skein: Twat**
2014
46 x 31 cm, pencil drawing on Mylar
mounted on aluminium

# FLOCK

Discovering so many birds within the embroidery works, Maier decided to play with the height of the gallery. *Flock* sores metres above the viewers' heads. A small bird, found at eye level at the tail end of *Flock*, gives the only clear view of the intricate detail present within each drawing. Mimicking the way in which birds are often seen, identified and appreciated from afar, binoculars are offered to the audience to view the bird drawings in detail.

**Flock: Muff**
2014
31 x 31 cm, pencil drawing on Mylar
mounted on aluminium

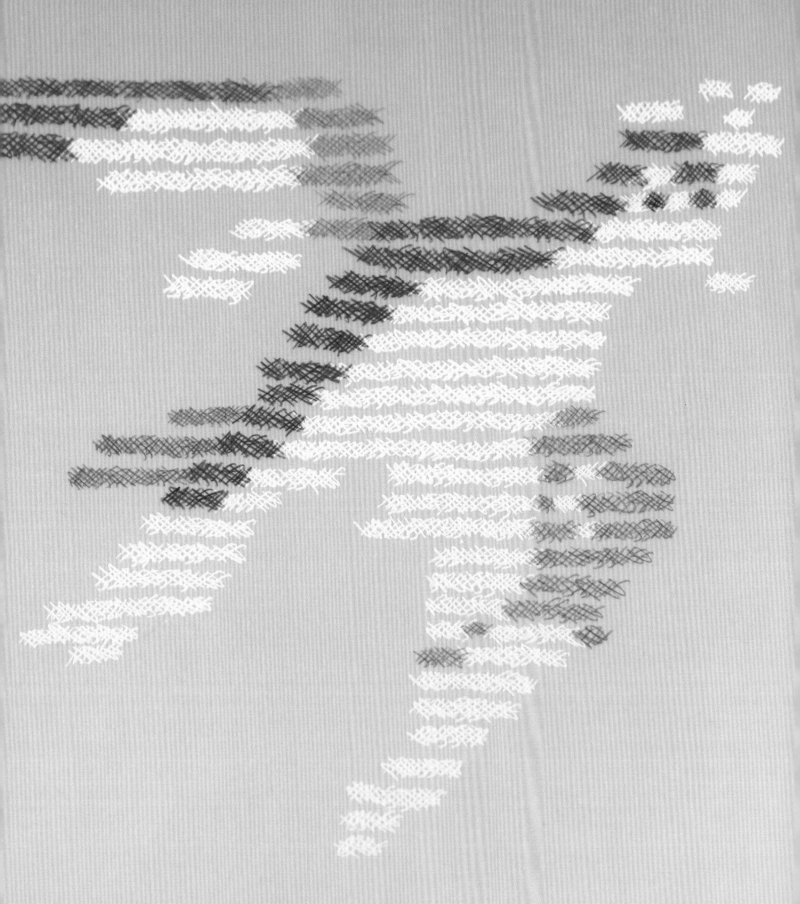

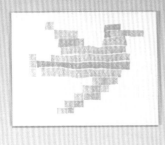
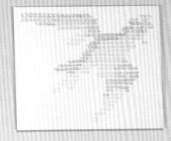
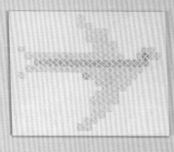
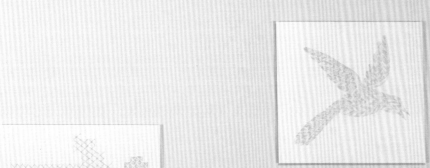

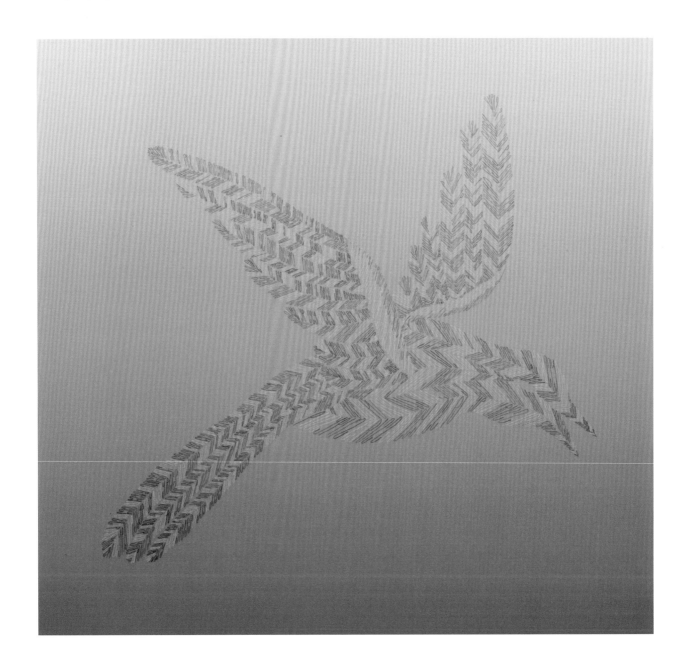

**Flock**
2014
5 x 8 mt, Composite installation of pencil drawings
on Mylar mounted on aluminium
The Collection Museum

**Flock: Herringbone Pussy**
2014
49 x 46 cm, pencil drawing
on Mylar mounted on aluminium

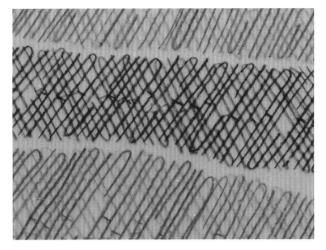

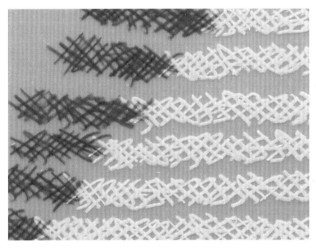

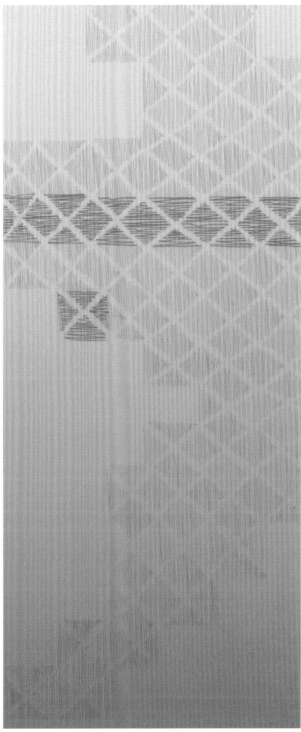

top
**Flock: Chat (detail)**
**2014**
49 x 38 cm, pencil drawing on Mylar
mounted on aluminium

middle
**Flock: Civen (detail)**
**2014**
53 x 38 cm, pencil drawing on Mylar
mounted on aluminium

bottom
**Flock: Muff (detail)**
**2014**
31 x 31 cm, pencil drawing on Mylar
mounted on aluminium

right
**Flock: Mink (detail)**
**2014**
53 x 41 cm, pencil drawing on Mylar
mounted on aluminium

**Flock: Poes**
**2014**
20 x 16.5 cm, pencil drawing on Mylar
mounted on aluminium

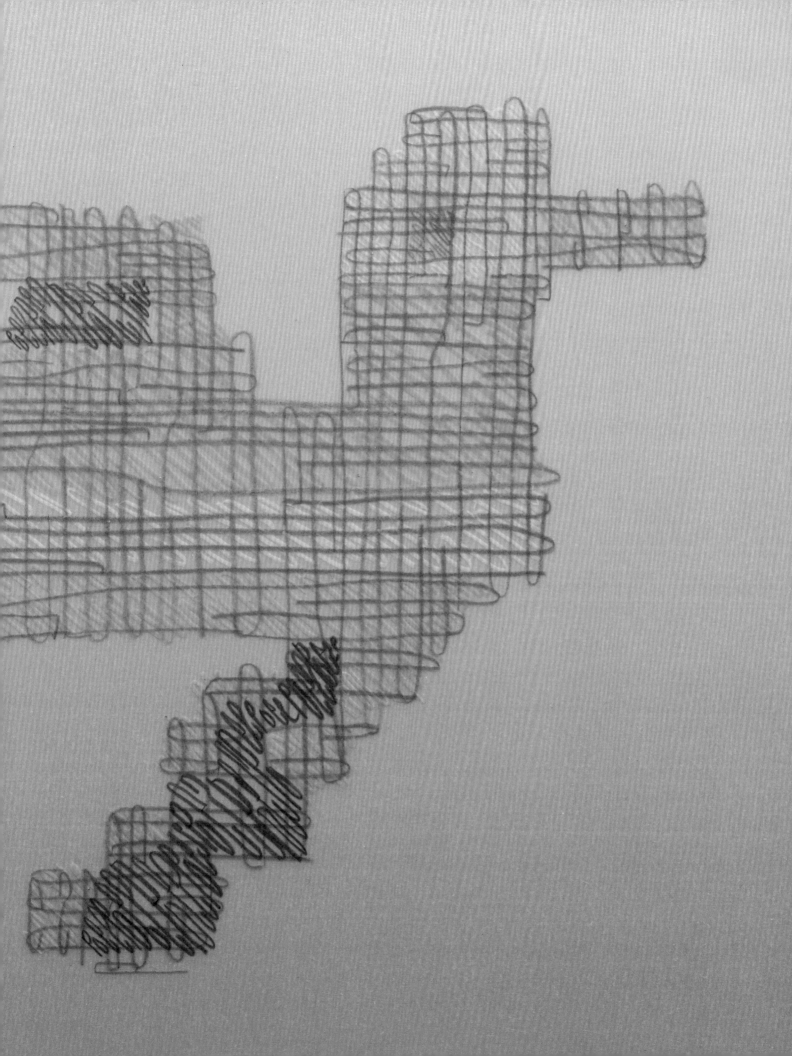

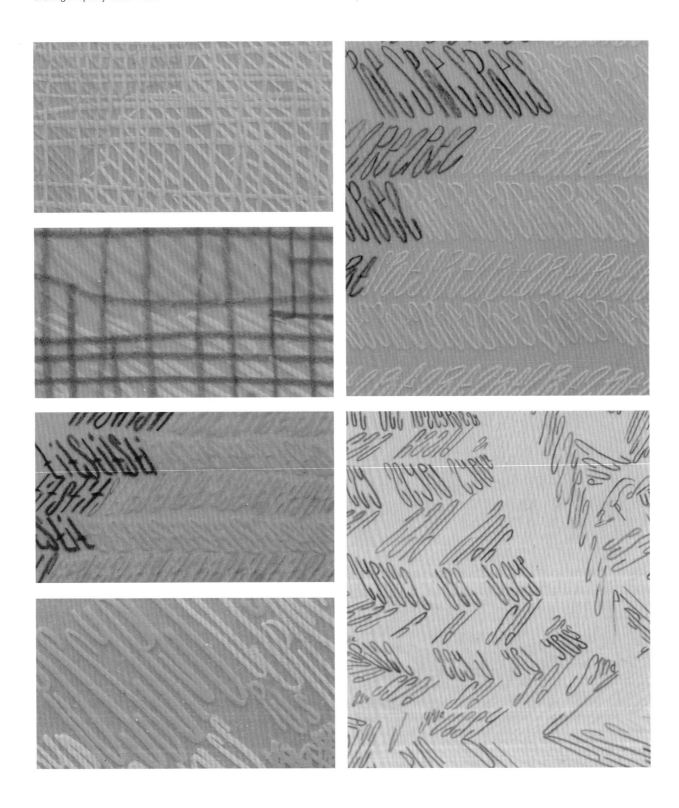

left from top to bottom
**Flock: Poozel (detail)**
2014
44 x 38 cm, pencil drawing on Mylar
mounted on aluminium

**Flock: Poes (detail)**
2014
20 x 16.5 cm, pencil drawing on Mylar
mounted on aluminium

**Flock: Red Tit (detail)**
2014
20 x 16.5 cm, pencil drawing on Mylar
mounted on aluminium

**Flock: Pink Pussy (detail)**
2014
20 x 20 cm, pencil drawing on Mylar
mounted on aluminium

right from top to bottom
**Flock: Poes (detail)**
2014
20 x 16.5 cm, pencil drawing on Mylar
mounted on aluminium

**Flock: Herringbone Pussy (detail)**
2014
49 x 46 cm, pencil drawing on Mylar
mounted on aluminium

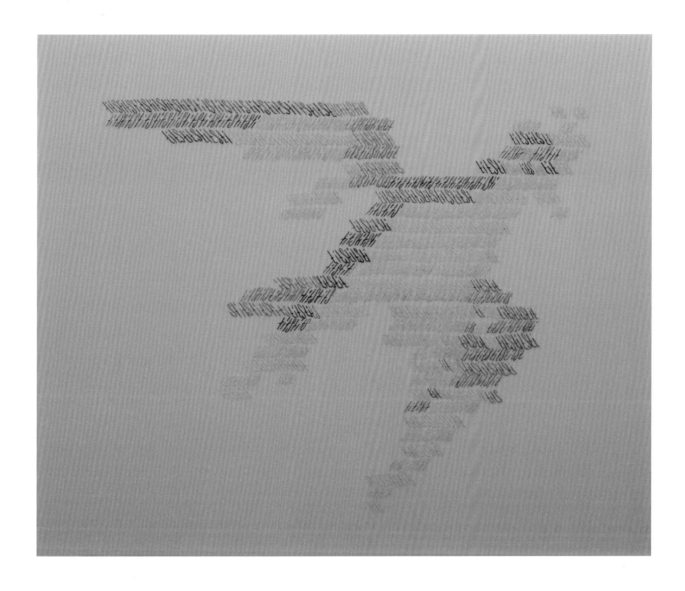

**Flock: Red Tit**
**2014**
20 x 16.5 cm, pencil drawing on Mylar
mounted on aluminium

# F***ing Homework: Danica Maier's Art of Domestic Subversion

## LISA VINEBAUM

This essay begins with a conclusion: Danica Maier's work is both unsettling and provocative. It unsettles some of what we have come to think about the histories of women's domestic sewing, and it provokes new understandings of the domestic and the decorative as sites for women's self-assertion. This essay does not describe Maier's work in substantial detail, nor is it intended to explain the work, for the artist wants you to embark on your own process of discovery, to look closely, to draw your own conclusions. Instead, this text provides some insight into the complex histories that can inform a deeper understanding of the work: the gendered histories of women's needlework that serve as material for artistic production; the domestic as a space for discursive formation; and the politics of homework, especially when it is gendered and classed, undervalued and unpaid. This text is written to *support* the art work, in keeping with performance scholar Shannon Jackson's notion of support: that which sustains the work and brings it into the realm of the socially engaged; that which connects it to other artworks, audiences, spaces of viewership, institutions, history, discourse, politics, and everyday life.[1]

The body of Maier's work presented here in *Grafting Propriety* takes the form of drawing, yet is closely aligned with textiles and with sewing in particular. Maier responds to the loaded, coded histories of the domestic crafts—objects that women made, collected, decorated, and used in the home: samplers sewn in eighteenth- and nineteenth-century England and America; an ornately hand-embroidered crewel Jacobean bedspread; 'willow ware' dinner plate patterns; and floral fabrics by the iconic British designer Laura Ashley. Maier uses the drawn line to reinterpret traditional, decorative motifs and patterns, isolating and emphasising specific details, reconfiguring and rearranging overall patterns, and playing with design, composition, scale and site. Pattern is contingent on the notion of repetition; through drawing, Maier enacts a type of repetition that is interpretive rather than mimetic, harnessing the repetitive act of mark making to produce new patterns or 'repeats'. Maier transforms stitched surfaces into hand-drawn lines, expanding miniature stitches into monumental works, and interrogating ideas of what stitch is and the spaces it may rightfully occupy. The work is playful, provocative, and polysemic, drawing us in to reveal unexpected imagery and meanings, and by extension, proposing new possibilities for thinking about needlework, the domestic, and the decorative. In so doing, the artist joins other contemporary artists like Anne Wilson, Karen Reimer, Ghada Amer and Reza Farkhondeh, who use drawn and stitched lines to unpick stereotypes about domestic labour and women's pleasure.

## SEWING SELVES

Both literally, as when the artist exhibits large and small-scale drawings in tandem with historical textiles, and more metaphorically, as when she uses them as a point of departure, Danica Maier's work engages the complicated histories of

women's material culture. Simultaneously embracing and subverting needlework, she creates physical and discursive spaces for thinking about the authorial aspects of sewing, and by extension, women's rhetorical agency.

Feminist scholars, most notably Roszika Parker and Jennifer Harris, have analysed the role of sewing as a normative force associated with the inculcation of Western ideals of femininity.[2] Men and women alike practiced needlework until the seventeenth century, when men's needlework was professionalised, and women's domesticated.[3] Sewing became more closely associated with femininity during the Victorian era, with its ideals of rigid gender roles and a renewed insistence that women work inside the home. There is nothing inherently feminine about craft or needlework: as Roszika Parker and Griselda Pollock remind us, the feminine is the product of a patriarchal culture that constructs male dominance by enforcing specific differences between the sexes. They further note that ideal feminine traits such as piety, chastity, submissiveness, delicateness and the decorative are not natural characteristics, but rather, ideological and socially imposed.[4]

Sewing came to be considered women's work at a time when larger shifts were taking place in the economy—with industrialisation and the rise of the capitalist marketplace—and in the realm of art—with an increased focus on the individual maker—and women came to be excluded from both. As Maureen Daly Goggin asserts, "within the world of the needle as elsewhere, men were understood to create, women to mend and tidy up".[5] Indeed, Pollock and Parker trace a history of women's exclusion from the world of art and their relegation to the sphere of domestic craft, while Clive Edwards notes that by the mid-eighteenth century, women's creativity was directed at the home.[6]

With the rise in industrial production of cloth came a corollary decline in the amount and types of textile work performed by women in the home; sewing came to be viewed as an appropriate leisure activity for middle class women, and would provide respectable employment skills to women of few or modest means.[7] Sewing skills, practiced and evidenced in samplers, were varyingly indicative of femininity and gentility, good upbringing, family status, marriage potential, domestic ability, and employability. While fulfilling socially proscribed norms, needlework also enabled women to "intentionally make some sort of personal statement with their work", for example, through individual interpretations of pattern and design, choice of colours and fabrics, and the incorporation of text. At a time when women had very little if any access to public sites of discourse, needlework provided a space in which women might speak and be heard.[8]

## THE NEEDLE AS AUTOBIOGRAPHICAL DEVICE

Feminist scholars such as Victoria Mitchell, Janis Jefferies and Elaine Showalter have explored the etymological, semiotic and material intersections between text and textiles. Both terms can be traced back to the Latin *texere*, to weave, an etymology that can also be linked to Greek and Sanskrit associations with making and forming.[9] As Mitchell importantly asserts, "language and textile formation share pliability as well as an inherent capacity to form structural relations between components".[10] Notably, the strategies of piecing and patching associated with quilting find echoes in "the techniques of literary piecing" found in women's writing.[11] Other scholars highlight connections between quilting and narrative structures: artists Miriam Schapiro and Melissa Meyer note that the quilt is a record of women's lives, while scholar bell hooks describes African American quilting traditions as a type of storytelling.[12] Needlework was used to mark household items like linens, tablecloths and napkins, but also, as a semiotic tool to mark and record women's lives and lived experiences.

The domestic has long been a site for women's subjugation and silencing, sometimes by way of repetitive labour, and sometimes by way of cruelty and violence, and the traditional sampler bears witness to both. Text was a common feature of eighteenth- and nineteenth-century samplers, which were often signed by the maker, at times recording important events in her own life and words.[13] A most compelling example is a sampler created by Elizabeth Parker at the age of 17, circa 1830. Parker's minutely stitched life story, told in 46 lines of tiny red cross-stitches, reveals her suffering at the hands of her employer, who abused her physically, sexually and emotionally. At a time when women were expected to be chaste and pure, submissive and silent, sewing was the only avenue available for Parker to tell her story, and her sampler is part autobiography, part confession, and part testimony.[14]

Very few samplers survived, and today little is known about their makers.[15] Indeed, this is true of samplers studied by Maier during her seven-month research residency in the textile archives of the Usher Gallery at the Collection Museum, Lincoln. Archival records describe the contents of the samplers, providing cursory information about colours, fabrics, threads, motifs and stitches—yet provide few details about the young women and girls who made them—only their names, and only when they were stitched into the samplers. Most historical samplers and textiles remain in archival storage and are rarely seen by members of the general public. By incorporating them into her works, Maier brings new visibility to these objects and those who made them. She provides us with a rare opportunity to view the artefacts, while putting them into dialogue with contemporary forms of mark making, and by extension, contemporary modes of spectatorship. In bringing these

cleaning, washing, ironing, baking, sorting, disposing, gardening, storing, sewing, crocheting, lacing, embroidering, knitting, tatting... all required a good deal of persistence and patience, and they were all to be performed repetitively but delicately.[18]

For Clive Edwards, because crafting and collecting enabled women to personalise their homes, they also provided a sense of agency over the home, representing a type of space-making but also, self-making.[19] While the home has often been a site of women's oppression and segregation, it has at also been a place for women's self-assertion. Similarly, needlework has also operated as a contradictory means of both women's subjugation and emancipation.

During the 1960s and 1970s, feminist artists like Su Richardson, Faith Ringgold, and Miriam Schapiro turned to needlework and craft as part of efforts to eradicate gender oppression, recognise women's unpaid labour in the home, and politicise divisions between public and private spaces. Artists used textiles exactly because of their historical associations with women's domestic craft and women's domestic work—often including the very quilts, diapers and laundry associated with women's unpaid and unrecognised labour in their art works. As Janis Jefferies asserts, "The decorative, craft and the domestic became challenging ideas that women in the fine arts could engage through work involving textiles".[20] During the late 1970s and into the 1980s, the Pattern and Decoration movement used cloth, pattern, and the decorative to subvert gender hierarchies and eradicate distinctions between art and craft, Western and non-Western art, public and private spaces, and art and everyday life.[21] Its artists were also deeply concerned with spectatorship and maintaining the attention of the viewer, turning to pattern and the decorative as a "very different mode of looking and visual attentiveness... a leisurely and less focused scanning for detail that our own culture denigrates and genders".[22]

## WHAT YOU SEE IS NOT NECESSARILY WHAT YOU GET

Stepping into an installation or standing in front of works by Danica Maier, the viewer is surrounded and confronted by patterns—of flowers, birds, animals, foliage and ornamental borders—patterns that have come to be associated with the decorative and the domestic, patterns that are often used in the home in wallpaper, upholstery, bedspreads, dinnerware and curtains. Step a bit closer, and one will see that the patterns are comprised of lines, lines that appear to be sewn and stitched. Closer even, and one may notice that the lines are not stitched but drawn, and that the lines are not lines, but letters. This type of attentiveness will pay off for those who choose to truly look and see, as letters form words—words associated with slang and sex and pleasure and privates.

Writing in 1975, the critic Amy Goldin noted that pattern is not so much about the repetition of motif, but about the "constancy and space between the motifs".[23] The empty spaces between composite parts that comprise the overall pattern are just as important for the creation of motif and meaning as the pattern itself. Our work as viewers is to complete the pattern—to fill in the spaces provided by the artist, to insert our own readings and understandings into Maier's work.

Danica Maier's works unpick the very notion of the ideal home and the ideal homemaker; as the artist astutely observes, such ideals are illusory and impossible to achieve[24]. As such, the works propose new patterns of domestic life. Ever aware of the gendered histories of sewing and needlework, Maier's work fits comfortably within Roszika Parker's notion of the subversive stitch.[25] But what happens when the subversive stitch is not a stitch but a drawn line? Maier plays with our expectations— of sewing, drawing, site, material and meaning. Through the repetitive act of drawing, she invokes needlework strategies of piecing, piercing, unpicking and assembling, in an effort to play with other types of making and unmaking, namely, that of personal and collective identity and modes of being, reminding us that sometimes things are not as we expect them to be. Maier's work involves a certain "defamiliarization of the familiar"—as such it is both unsettling and provocative.[26] Maier unsettles gender expectations and the hierarchies and binaries that have served to delineate spaces, subjectivities, and modes of production: private/public; visible/invisible; sewing/drawing; proper/improper. In so doing, Maier creates playful spaces for subversion and the insertion of subversive personal narratives. She opens up spaces for self-assertion and agency, and she explores the domestic as a site for women's sexual assertion and women's sexual pleasure. In confronting the viewer with such obvious pleasure, she provokes us to reflect on what we see, and by extension perhaps, how we see ourselves.

1  Shannon Jackson, *Social Works: Performing Art, Supporting Publics*, London and New York: Routledge, 2011.

2  Roszika Parker, *The Subversive Stitch: Embroidery and the Making of the Feminine*, London: The Women's Press, 1984. Jennifer Harris, "Embroidery in Women's lives 1300-1900", The Subversive Stitch, ex cat, Manchester: Whitworth Gallery and Cornerhouse, 1988, pp 7–34.

3  Maureen Daly Goggin, "Stitching a Life in "Pen and Silken Inke": Elizabeth Parker's circa 1830 Sampler", *Women and the Material Culture of Needlework*, Maureen Daly Goggin and Beth Fowkes Tobin eds, Farnham: Ashgate, 2009, pp 31–50.

4  Griselda Pollock and Roszika Parker, *Old Mistresses: Women, Art and Ideology*, London: Pandora, 1981.

5  Daly Goggin, *Women and the Material Culture of Needlework*, pp 41.

6  Pollock and Parker, *Old Mistresses: Women, Art and Ideology*; Clive Edwards, 2009.

7  Aimee E Newell, "'Tattered to Pieces': Amy Fiske's Sampler and the Changing Roles of Women in Antebellum New England", *Women and the Material Culture of Needlework*, Maureen Daly Goggin and Beth Fowkes Tobin eds, Farnham: Ashgate, 2009, pp 51–68.

8  Heather Pritash, Inez Schaecterle and Sue Carter Wood, "The Needle as Pen: Intentionality, Needlework, and the Production of Alternate Discourses of Power", *Women and the Material Culture of Needlework*, Maureen Daly Goggin and Beth Fowkes Tobin eds, Farnham: Ashgate, 2009, pp 13–30: 15.

9  Victoria Mitchell, "Textiles, Text and Techne", *Textiles: Critical and Primary Sources Volume II*, Catherine Harper ed, London: Bloomsbury, 2012, pp 159–168.

10 Mitchell, *Textiles: Critical and Primary Sources Volume II*, p 160.

11 Elaine Showalter, "Piecing and Writing", The Poetics of Gender, Nancy K. Miller ed, New York: Columbia University Press, 1986, pp 222–247: 229.

12 Melissa Meyer and Miriam Schapiro, "Waste Not Want Not: An Inquiry Into What Women Saved and Assembled - FEMMAGE", *Heresies* #4, 1978, pp 66–69; hooks, bell, "An Aesthetic of Blackness: strange and oppositional Aesthetic Inheritances, history worked by hand", *The Object of Labor: Art, Cloth, and Cultural Production*, Joan Livingstone and John Ploof, eds, Cambridge Mass and London: The MIT Press, 2007.

13 Daly Goggin, *Women and the Material Culture of Needlework*.

14 Daly Goggin, *Women and the Material Culture of Needlework*.

15 Leena A Rana, "Stories Behind the Stitches: Schoolgirl Samplers of the Eighteenth and Nineteenth Centuries", *Textile: The Journal of Cloth and Culture*, Volume 12 Issue 2, pp 158–179.

16 Ana Araujo, "Repetition, Pattern and the Domestic: Notes on the Relationship between Pattern and Home-making", *Textile: The Journal of Cloth and Culture*, Volume 8, Issue 2, 2010, pp 180–201.

17 Edwards 2009.

18 Araujo, *Textile: The Journal of Cloth and Culture*, Volume 8, Issue 2, 2010, pp 186.

19 Edwards 2009.

20 Janis Jefferies, "Contemporary Textiles: The Art Fabric", *Contemporary Textiles: The Fabric of Fine Art*, in Monem, Nadine ed, London: Black Dog Publishing, 2008.

21 Norma Broude, "The Pattern and Decoration Movement", *The Power of Feminist Art: The American Movement of the 1970s*, Norma Broude and Mary D Garrard eds, Harry N Abrams, 1996, pp 208–225.

22 Broude, *The Power of Feminist Art: The American Movement of the 1970s*, pp 220.

23 Broude, *The Power of Feminist Art: The American Movement of the 1970s*, pp 216.

24 Conversation with the Danica Maier, January 2015.

25 Parker, *The Subversive Stitch: Embroidery and the Making of the Feminine*.

26 Daly Goggin 2009, p 40.

Pussy
Willow

following pages
**Pussy Willow (left part)**
2013
89.5 x 62 cm, pencil drawing on Mylar
mounted on aluminium

**Pussy Willow (middle part)**
2013
79.5 x 62 cm, pencil drawing on Mylar
mounted on aluminium

**Pussy Willow (right part)**
2013
89.5 x 62 cm, pencil drawing on Mylar
mounted on aluminium

*Pussy Willow* takes five different historical 'willow ware' plate patterns as the starting point. From these Maier has created a new idyllic landscape using the motifs found within the original designs. Her interest arises from the range of diverse willow patterns that were produced by different factories, all using similar, equivalent markings. In Maier's version lovers have become a gathering flock; hills have transformed into mountains; forests disappear into the distance while the familiar trees remain in the foreground.

*Pussy Willow* is exhibited in three parts using three existing outdoor public noticeboards, so that each panel thereby becomes geographically distant from the next. Fragmenting the drawing in this way, obliges the viewer to rely on memory when viewing the next segment. This work was produced in 2013 as part of the major international research residency project Topographies of the Obsolete that took place within, and responded to, the now abandoned Spode factory in Stoke-on-Trent. It was then exhibited as part of Topographies of the Obsolete: Vociferous Void alongside that year's British Ceramics Biennial. This initiative was led by Bergen Academy of Art and Design, Norway.

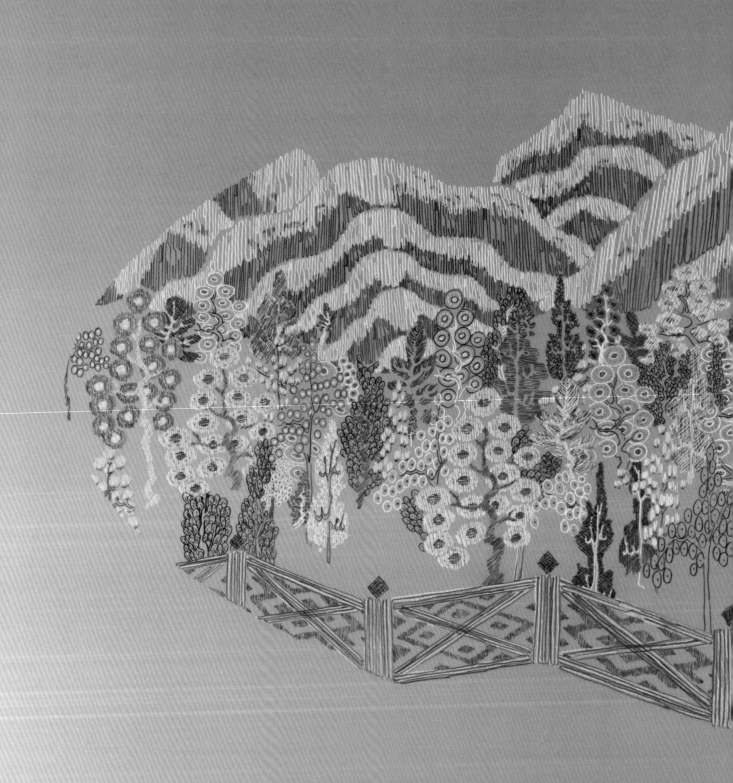

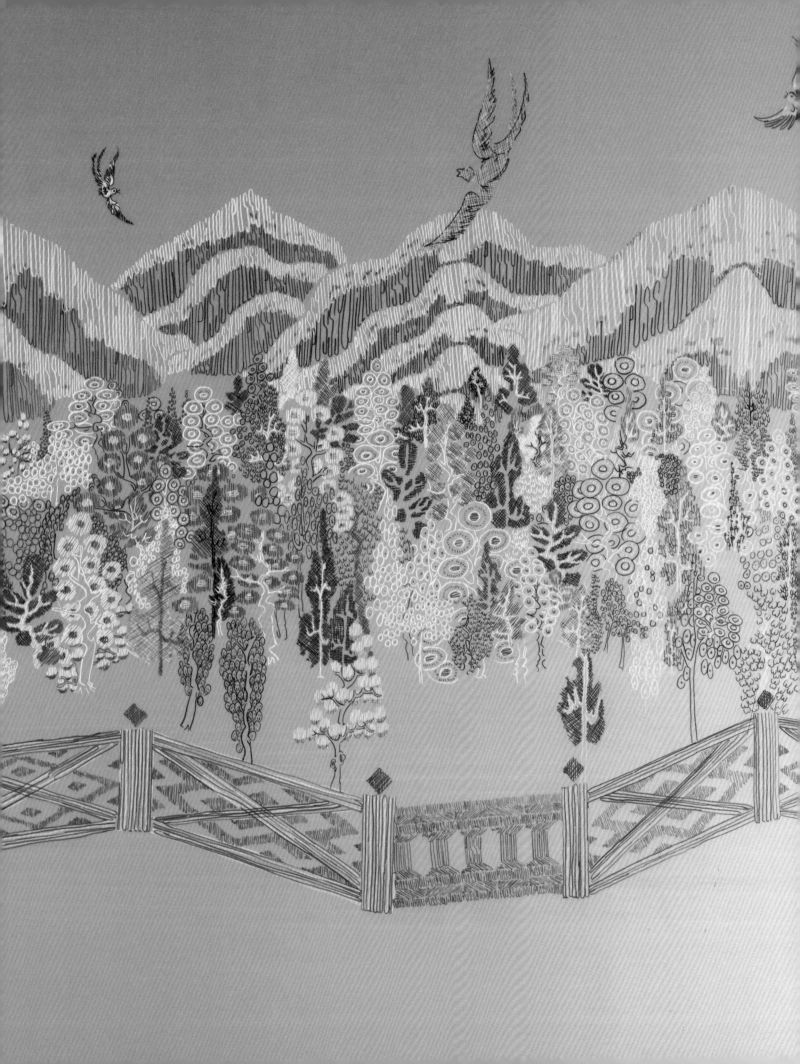

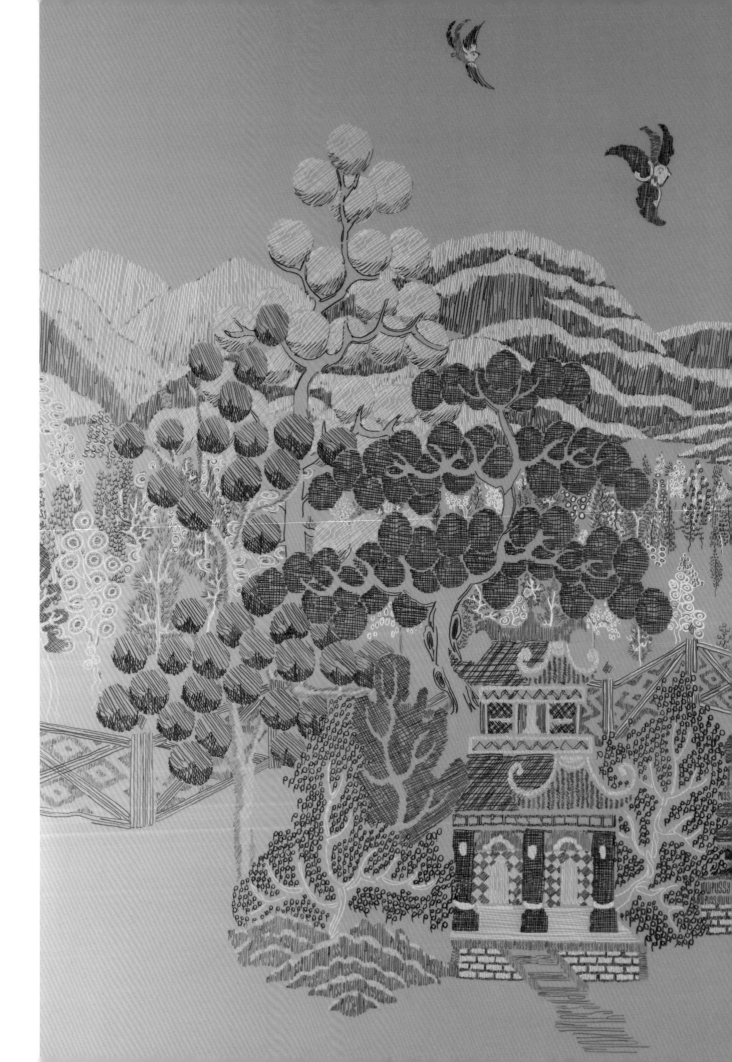

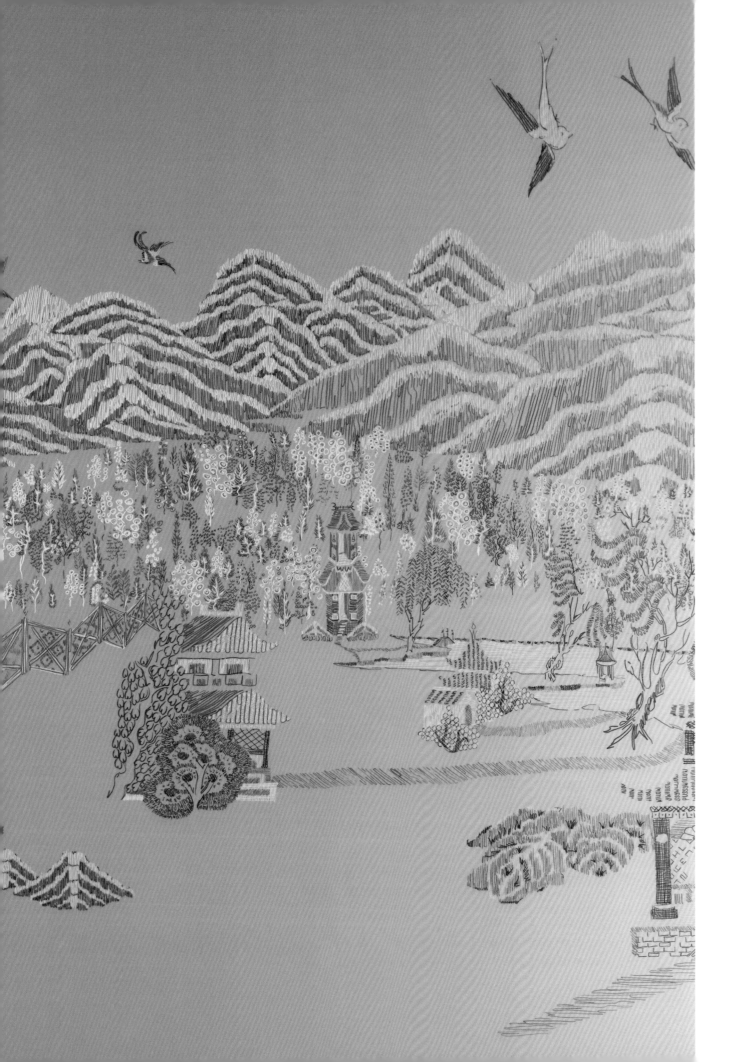

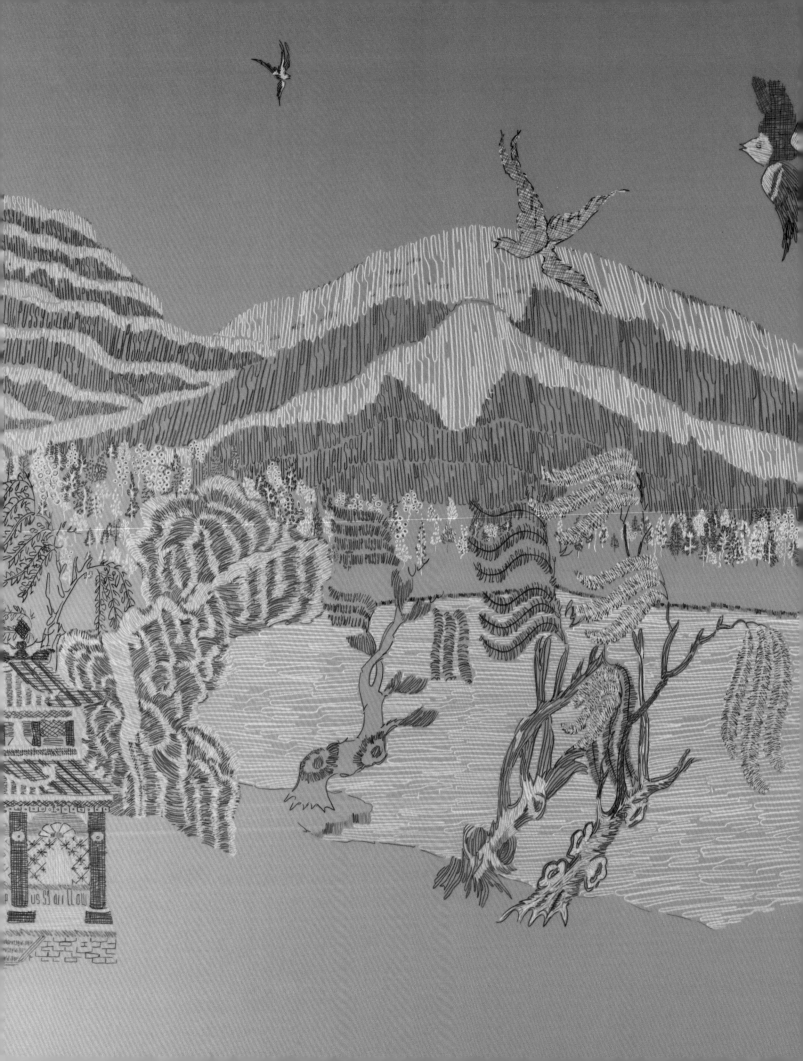

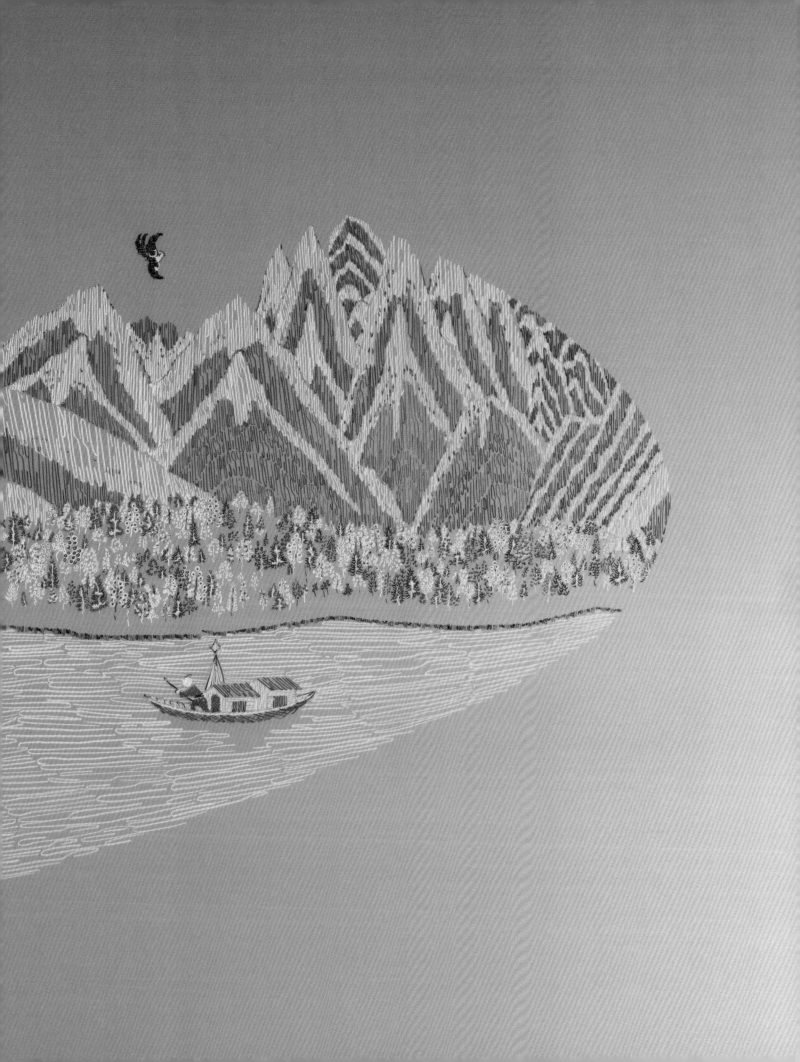

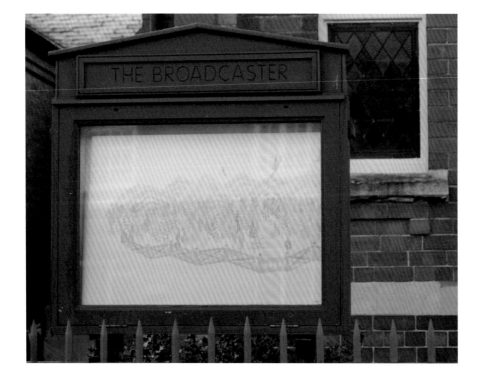

**Pussy Willow: The Broadcaster
installation Waddington**
2013
pencil drawing on Mylar mounted
on aluminium

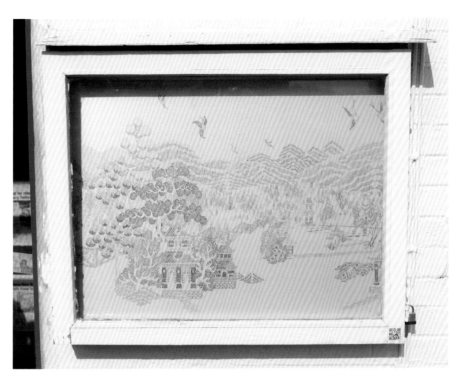

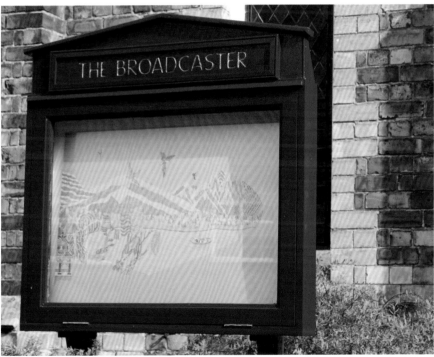

**Pussy Willow: Topographies of
the Obsolete, abounded Spode
Factory installation**
2013
pencil drawing on Mylar mounted
on aluminium

**Pussy Willow: The Broadcaster
installation Wellingore**
2013
pencil drawing on Mylar mounted
on aluminium

Mossy
Rose

pages 101 to 105
**Mossy Rose**
**2011**
125 x 125 cm, pencil drawing on Mylar
mounted on aluminium

*Mossy Rose* uses found fragments of various textile sources combined in collage. This single collage was then used to create all four panels, each panel working with similar treatments but each highlighting different details. Maier's pencil begins to playfully mimic various methodologies of weave and stitch while creating a frame within itself. Lakeside Arts Centre in Nottingham commissioned *Mossy Rose* for the exhibition Evolution of Stitch.

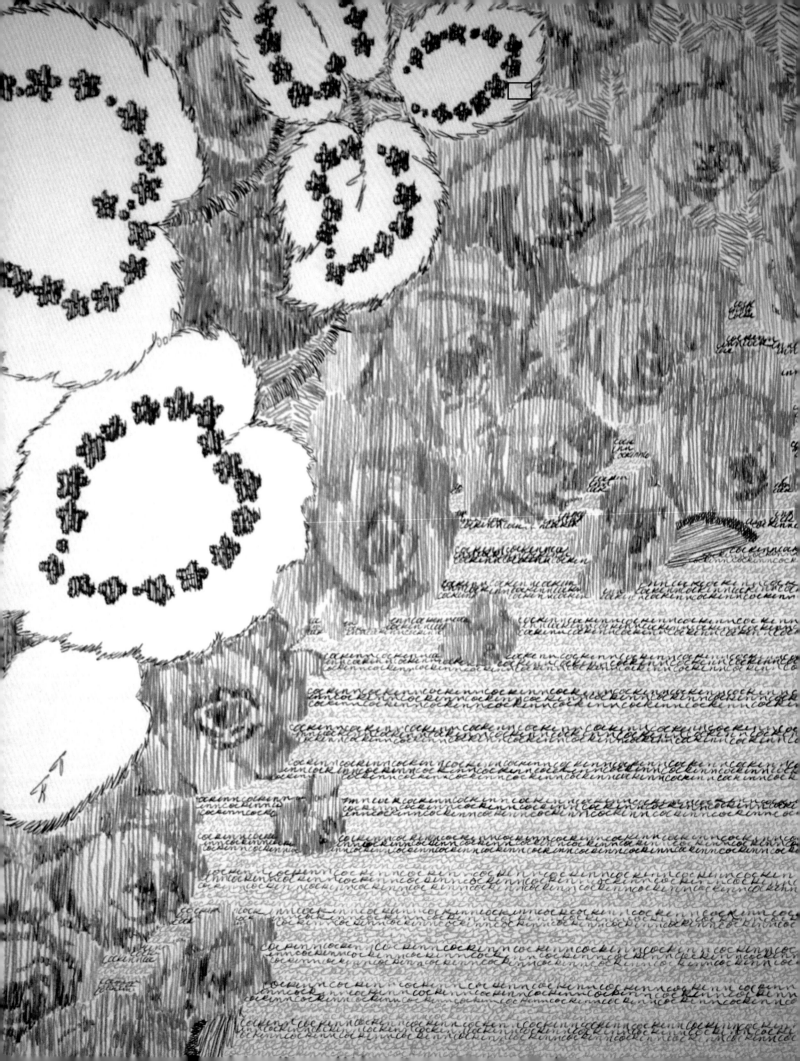

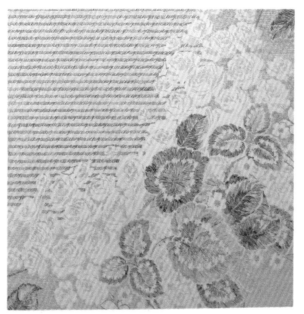

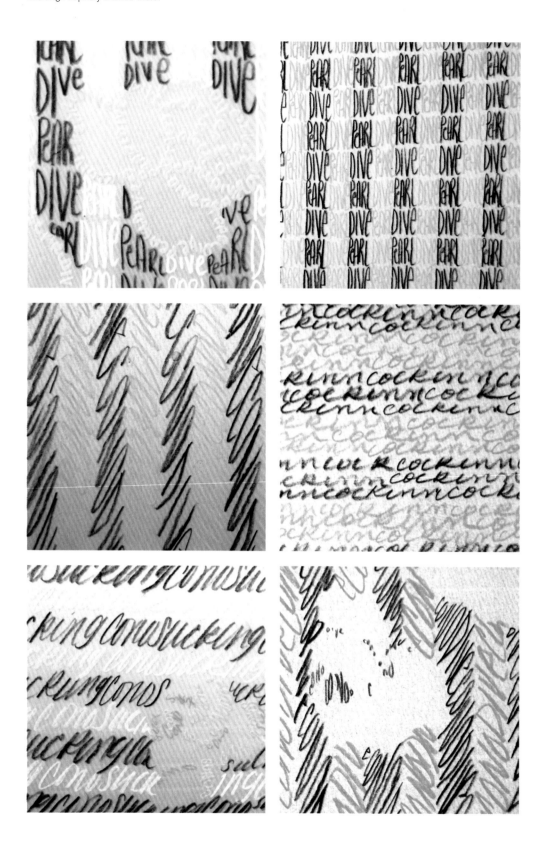

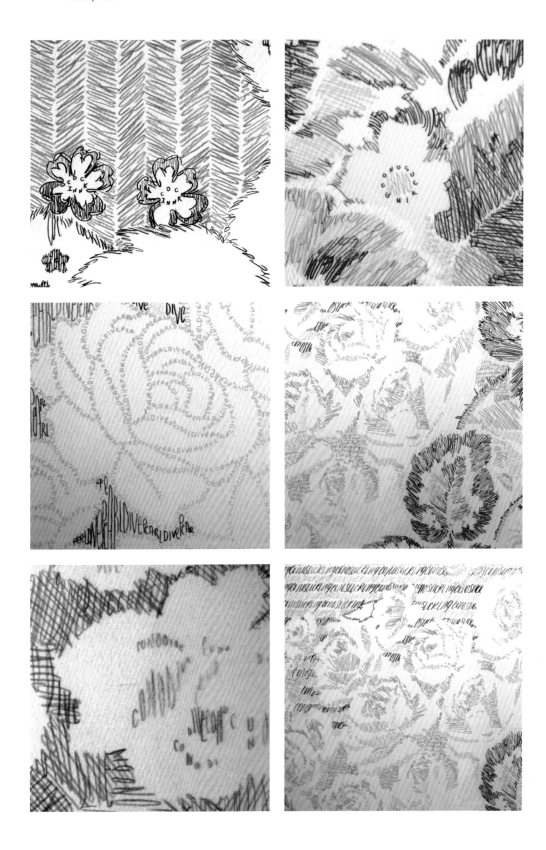

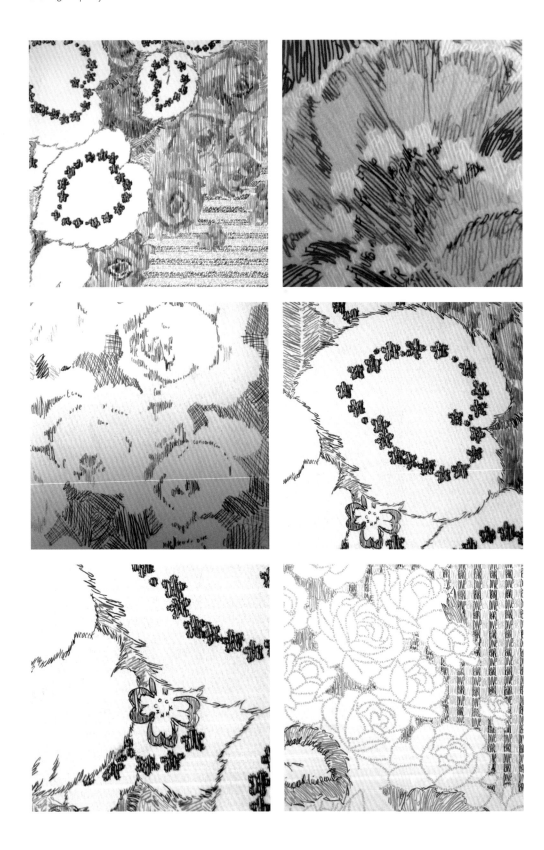

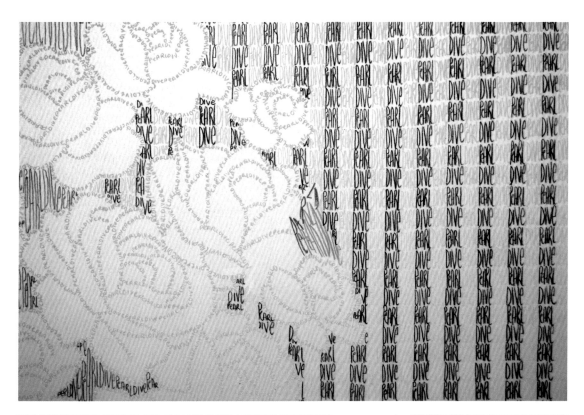

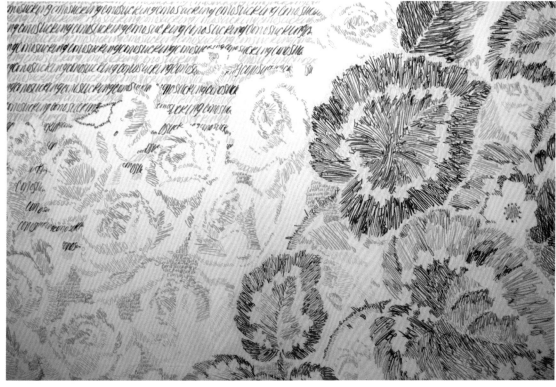

# Line on
# Line

## DANICA MAIER

## MINOR MOMENTS

Subtle slippages between the expected, minor moments found in the comings and goings of everyday life, discovered only through close observation. Attention and curiosity is needed to uncover these moments. Only through investing time and truly looking are details revealed. Hidden in plain sight, the domestic (whether pattern or object) is so familiar we forget to look at it. To really look, to pay attention to what is in front of us all the time. It sees you but do you see it?

The overlooked, the marginalised, the domestic have power. Slowing simmering up a revolution: a cauldron of stew won L'Escalade[1] in Geneva after all. Moments of detail transgress propriety; found hidden through a mass of line, these moments hold you as you begin to see. Propriety may be seen or expected through domestic pattern, the decorative, a stitched line. But what is proper, really? Politeness, correctness: are they not tools to hide what one really thinks.

## LINE OF THREAD - - - - - LINE OF PENCIL

A line is a line, isn't it? But drawn line cannot be like a physical line of thread: it can merely mimic stitch.[2] When stitching, a line of thread is held free with the help of the needle, travelling in and out of fabric. Woven fabric is simply lines stacked together vertically and horizontally, crossing over and under one another. The embroidered line[3] of thread goes around the fabric: lines around lines, lines holding lines, line piercing line, stitching over, under, over, under. Alternatively, the line of pencil sits on top of the page only crossing its own previously left lines; quickly and easily it can retrace its steps back to find the line left behind.

---

1   In the early hours of 12 December 1602, Savoyard soldiers launched a surprise attack on the walled city of Geneva, while the residents inside slept. Led by the Duke of Savoy, who desired the city of Geneva for his capital in the Northern Alps, this failed attempt was scuppered by the citizens preventing the soldiers from carrying out an *escalade* ("to scale the walls" in French). As legend has it key to halting the invasion was Catherine Cheynel (also known as "Mère Royaume") a mother of 14 and wife of Pierre Royaume, who was still awake cooking a stew in a large cauldron. Living above the town gates, she heard the Savoyard soldiers attack and proceeded to dump her cauldron (and boiling stew!) onto the head of an attacking soldier killing him and in the process rousing her fellow townspeople. Today Geneva still celebrates their historic triumph and remembers Mère Royaume. In early December the city shops are packed with chocolate cauldrons filled with marzipan vegetables and confectionary wrapped in red and gold. On 12 December, to commemorate L'Escalade, the locals celebrate by smashing the cauldron pots and sharing in the treats.

2   I know. I've tried.

3   But what of other domestic lines: the family tree (lineage); passing down of DNA (double helix lines); traits inherited from previous generations (worry lines); traditions carried on (rolling pin lines); heirlooms passed down (line of pearls).

Intention of the line, where is it found?[4] The line of thread holds the intention at the end, where the mark (stitch) has been left in the fabric. The line of thread is pulled further and further away from this point. The pencil line is the reverse, holding its intended mark at its tip.[5] Where the mark (line) has been started and left connecting with what has already been drawn, while the pencil moves further and further away, separated from the line. The pencil cannot be like the stitched line going around and around the page; its line is not attached like thread to a needle. So it adapts, mimics, copies the stitched line: impersonation is never easy, it needs many tricks to mimic the original. Complex lines and time are needed to tackle similar marks found in stitch.

## PATTERN, LINE, STITCH >< LETTER, WORD, TEXT

Writing as drawing: enjoyment in making the shapes of letters and words. Delicate actions, long sweeping gestures are used to create ornate text*line*. Flowing between meaning and image, the repetition of drawn words transform them into the visual[6]. Similar to calligraphy[7], the text*lines* are intended to be visual while retaining some legibility. Fluxing between meaning and image, the text*lines* are meant to "convey complexities of content without necessarily always spelling out the content for the viewer"[8].

Enjoyment in the labour of writing for a dyslexic may seem at odds but it is a transformative activity that produces shapes and lines. Pattern and line accumulate into words, repeated over and over. Words and letters dissolve into pattern, repeated

4    A question to contemplate while I draw and you read: line after line after line after line after line after line after line after line after line after line after line after line after line after line after line after line after line after line

5    Tongue tip, pencil tip, sharpened tip, sharpen your wit

6    *eeeeeeeeeeeeeeeeeeeeeeeeeeeeeeeeeeeeeeeeeeeeeeeeeeeeeeeeee*
*uuuuuuuuuuuuuuuuuuuuuuuuuuuuuuuuuuuuuuuuuuuuuuuuuuuuuuuuuuuuuuuuuuu*
*∂∂∂∂∂∂∂∂∂∂∂∂∂∂∂∂∂∂∂∂∂∂∂∂∂∂∂∂∂∂∂∂∂∂∂∂∂∂∂∂∂∂∂∂∂∂∂∂∂∂*
*ggggggggggggggggggggggggggggggggggggggggggggggggggggggggg*

7    My grandmother taught me the love of making in her sewing room (or studio as I now like to think of it) and my grandfather taught me calligraphy. Such enjoyment in the action of forming letter shapes and word forms; writing letters over and over again, to feel their twirl. (A habit I still have, margins of notes filled with individual repeated letters.) Writing that isn't about 'writing' but the visuals of text; think about how fonts can change one's reading of the content. My grandfather was an intelligent man but unable to afford university, so he attended one semester of handwriting classes. If he could not be educated, he could at least look it. Appear proper.

8    From an email conversation with Lisa Vinebaum, 17 January, 2015.

9  Living in a log cabin in the American outback, Fanny can't see the wood for the trees; she is blind to anything but the forest, blinded by the forest. The trees permeate everything, are too close without any edge. But what if she can't see the trees for the wood—only the big picture and no detail, a single mass of forest but not a single tree. How would you know what a forest is made from? The importance of being able to oscillate between the two is significant to understanding: seeing both forest and trees.

10  Sweet Stag, curled up in the corner on a small green mound, gentle cross-stitch gives the three-inch animal enough structure to hold him. But then BOOM, expanded to life size he encounters difficulty in both the stitch and the animal; he does not like to grow. Pixelated now beyond his appealing smaller self a grotesque creature is formed. From far off he still retains a trace of his smaller self but as you approach this begins to falter. Oscillating between a stitch, a pixel, a line, a thread, the Stag is mimicking as best he can. But up close he disintegrates back into the component units that make him up.

11  Now flipping back to metaphorically seeing just the trees—is this all one sees? How about further details found in those woods: the bear, fox, birds, squirrel, leaf, flower, bees, ant. But then looking too closely, nothing is seen · · · · · it dissipates into pixels. But what is that pixel, a beautiful stitch, a mark. Step back too see the whole and the detail disappears, move closer and the whole vanishes. When no detail is there, guess-work and structure are laid in place where the image usually is. Back and forth until perhaps something is captured, held onto, made real.

12  $\theta+1$ does not equal one... Bound together in the mind of the audience is where *the work* can be found; viewers take away something they cannot see all at once. For in the object *it* can never been captured in one moment, *it* exists somewhere between experience and memory. Reproduction cannot hold *the work*, documentation fails, there will always be something missing, different from the moment of viewing. More complex than *it* being there or not being there; getting *it* or not getting *it*; seeing *it* or not seeing *it*; on or off; yes or no; black or white. The viewer's experience of looking, seeing, finding, revealing, memory, betweenness, and beyond, cannot be captured, snapped, screen grabbed. And should not be.

# Harlequin
# Slit

*Harlequin Slit* is one of two works created as part of a research project and group exhibition, Closely Held Secrets at the Bonington Gallery, Nottingham in 2010. Embroidery machines were used to create the key components of the work. The project explores relationships between artist and technician, with a focus upon revealing the nature of hidden dialogues between the originator of an idea and the agent of interpretation. For her artwork Maier worked closely with technician Tessa Acti to develop machine stitches covering all but small details of the delicate silk beneath.

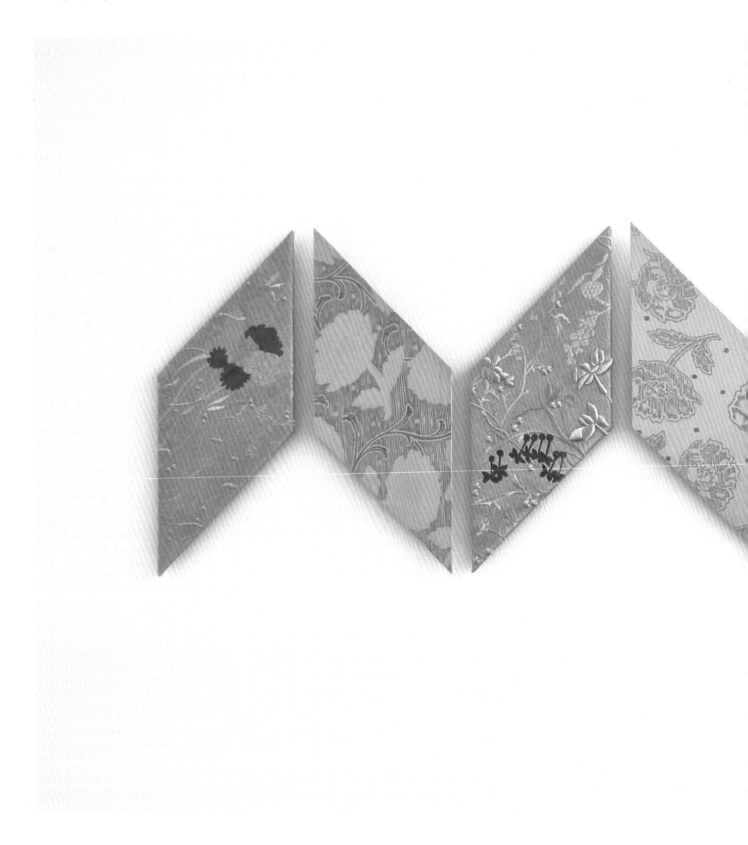

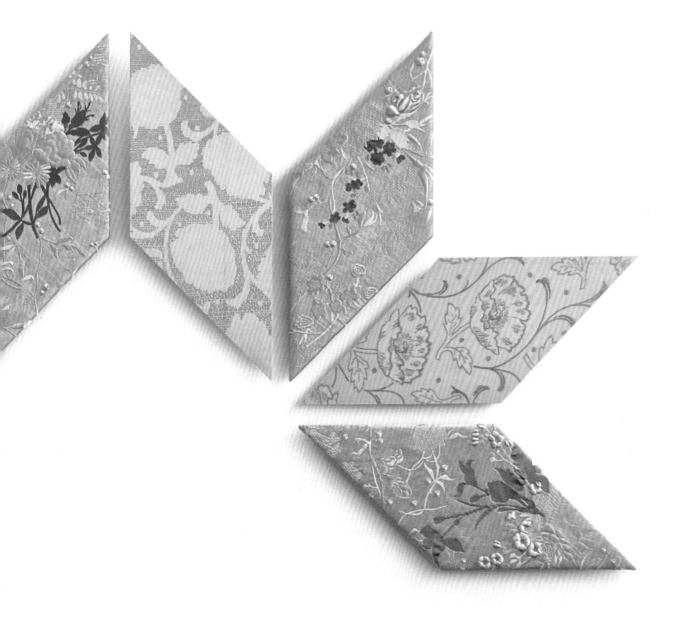

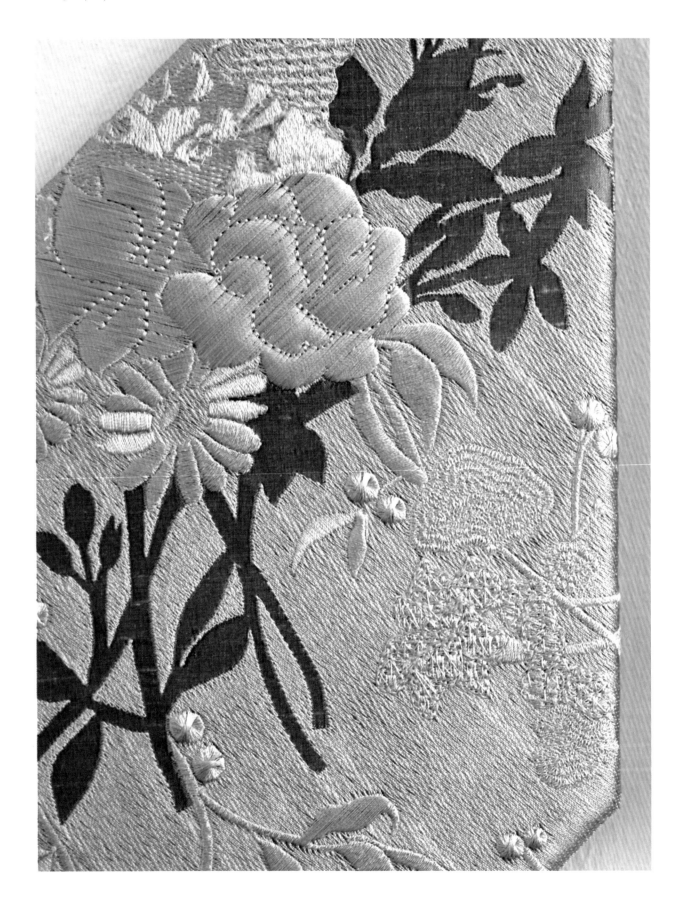

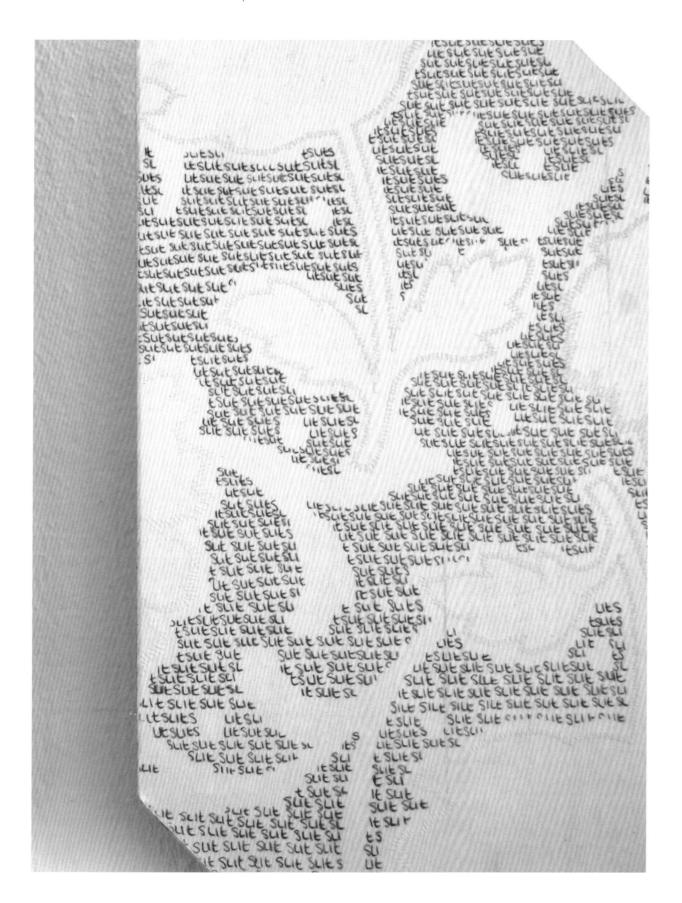

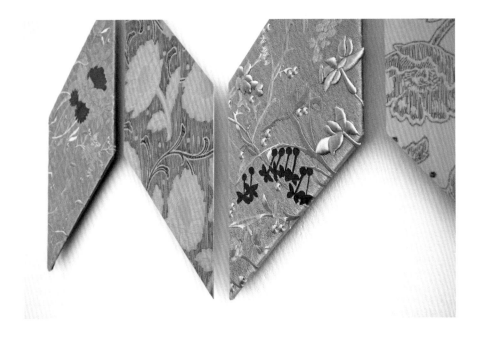

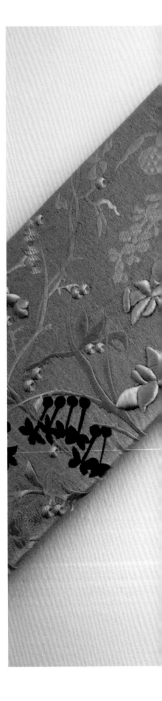

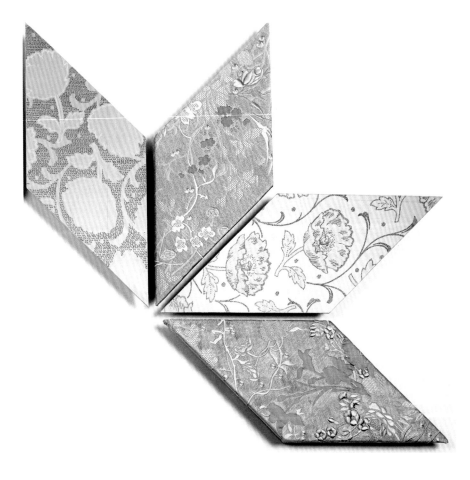

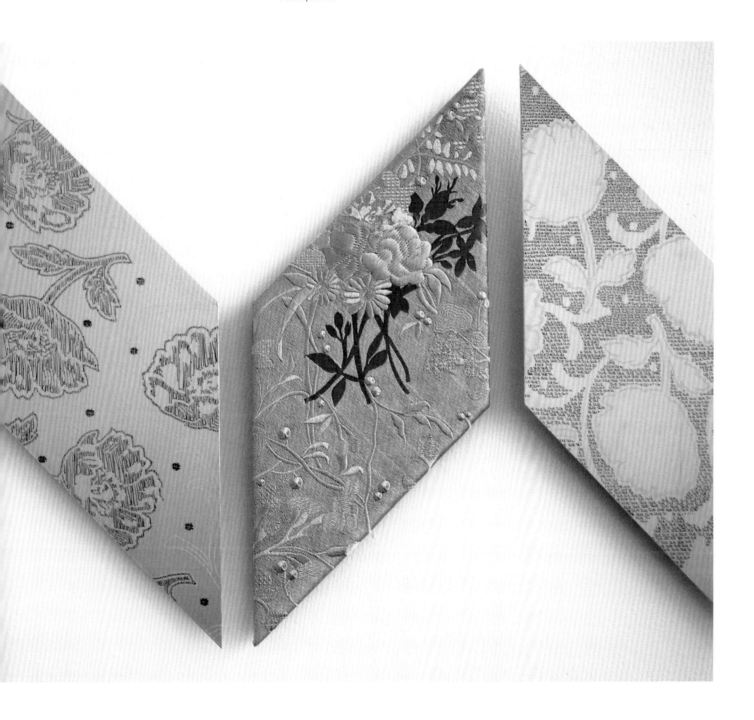

# Four
# Glory Holes

**Four Glory Holes**
**2007**
152.5 x 152.5 cm, pencil drawing on Mylar
mounted on aluminium

The panel drawing *Four Glory Holes* uses a historical fragment of an original artwork from the quintessential British textile designer Laura Ashley as its initial source material. Each rotation concentrates on different details, creating four 'originals' that are all unique yet each is of the same repeated image. Multiple readings of the work unfold as the viewer moves within the space: from the printed image, to stitch, to line, to text.

The piece was produced for an exhibition of UK-based artists entitled Unpicked and Dismantled, which was part of the Kaunas Art Biennial: TEXTILE 07. The exhibition focused on artists whose practices interrogate concerns, agendas and methodologies raised by textiles, but whose outcomes use means other than the materials and processes of textiles. The exhibition was shown in the National Museum of M.K. Ciurlionis, Kaunas, Lithuania and was co-curated by Danica Maier and Gerard Williams.

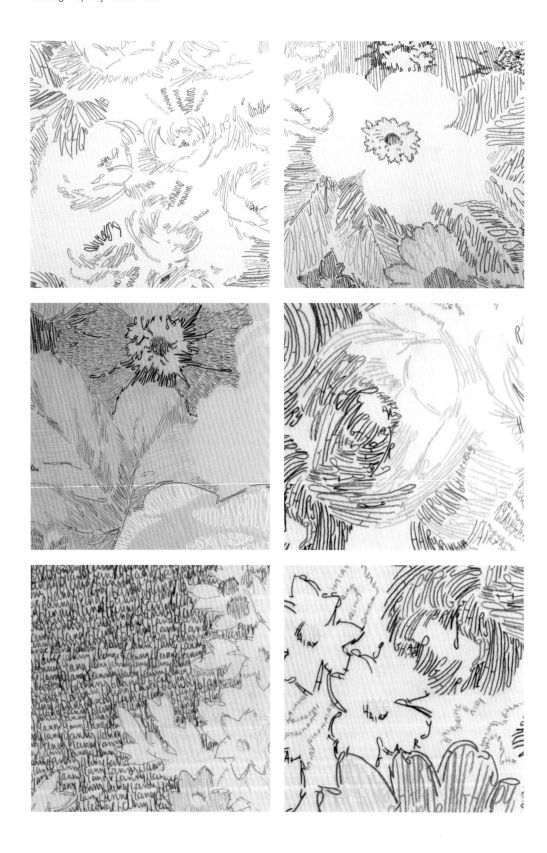

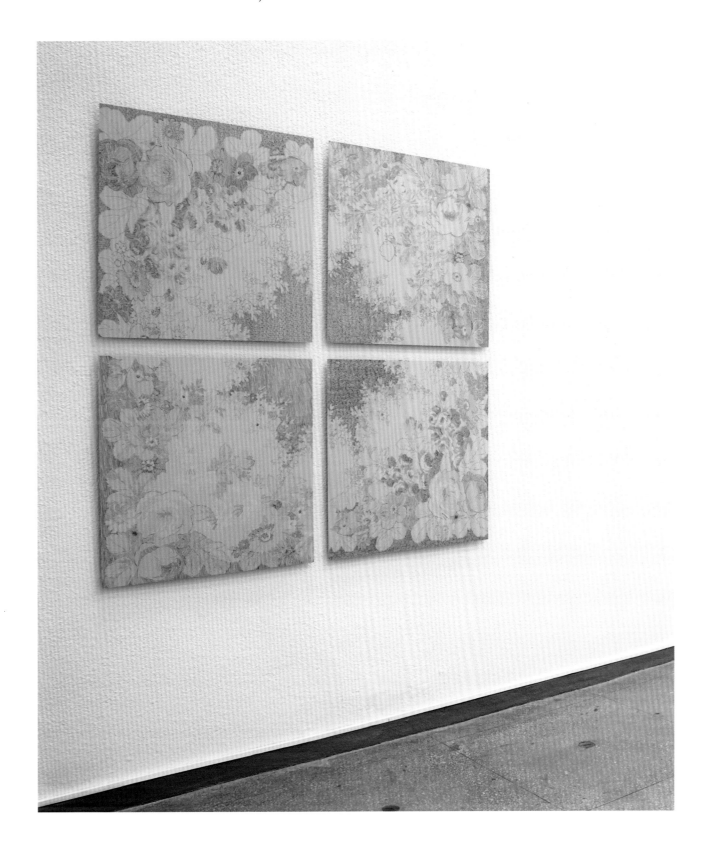

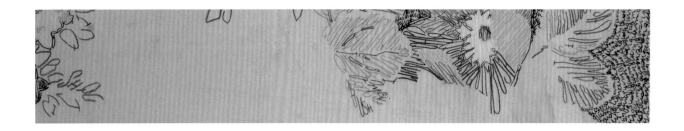

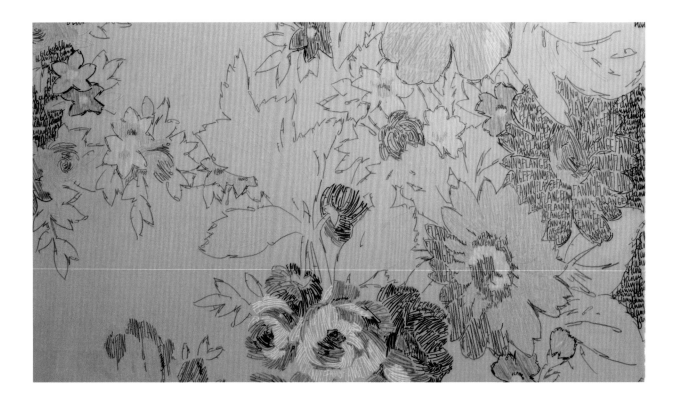

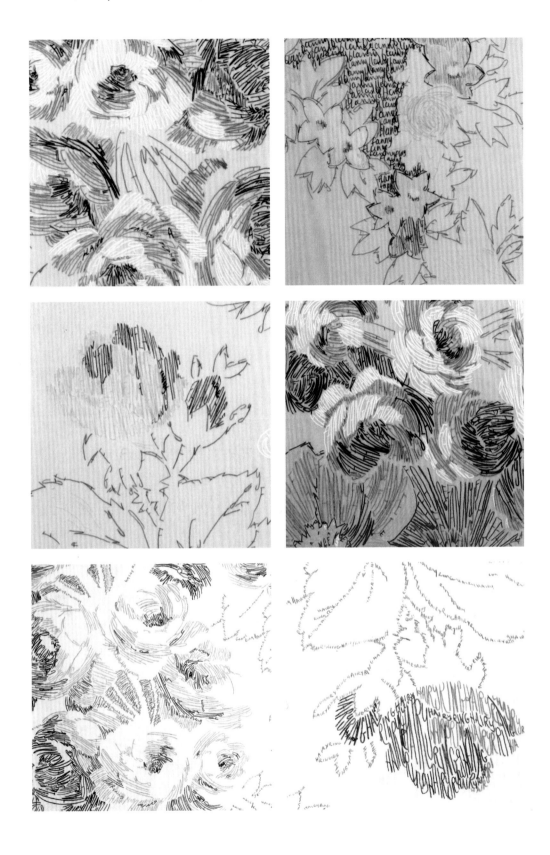

**Emma Cocker** is a writer-artist and Reader in Fine Art at Nottingham Trent University. Operating under the title *Not Yet There*, her research often addresses the endeavour of creative labour, focusing on models of (art) practice and subjectivity that refuse the pressure of a single, stable position by remaining wilfully unresolved. Cocker's recent writing has been published in *Failure*, 2010; *Stillness in a Mobile World*, 2010; *Drawing a Hypothesis: Figures of Thought*, 2011; *Hyperdrawing: Beyond the Lines of Contemporary Art*, 2012; *On Not Knowing: How Artists Think*, 2013; and *Reading/Feeling*, 2013. She has presented performance-lectures and video works internationally: including Flattime House, London; M_HKA, Antwerp; NGBK, Berlin; Stadtpark Forum, Graz; and AGORA: The 4th Athens Biennale.

**Danica Maier** is an artist interested in drawing, site-specific installations and events to explore ideas of expectations of site, traditional values, 'women's work' and labour. She completed an MFA in painting at University of Delaware before receiving an MA in Textiles from Goldsmiths, University of London. Maier has exhibited and curated exhibitions nationally and internationally including co-curated and exhibited in a major exhibition of the work of UK-based artists Unpicked and Dismantled, a part of the Kaunas Art Biennale. Maier has participated in numerous residency programmes including Braziers International Artist Workshop in the UK, was artist in residence at the Fundación Migliorisi in Asuncion, Paraguay, and did the apprenticeship at the Fabric Workshop and Museum in Philadelphia. She is currently working as a Senior Lecturer in Fine Art at Nottingham Trent University.

**John Plowman** is an artist whose practice encompasses both studio and curatorial activity through which he explores his interest in the production of art and the site(s) of its production and exhibition. Since 1980 he has exhibited in and curated numerous one-person and group exhibitions in this country and abroad. In 2004 he established the curatorial project Beacon which engages critically with the commissioning and presentation of contemporary art projects in non-gallery spaces offering a new perspective on art practice through collaboration between artist, audience and institution.

**Lisa Vinebaum** is an interdisciplinary artist, critical writer and educator. She holds a PhD in Art from Goldsmiths, University of London, an MA in Textiles also from Goldsmiths, and a BFA from Concordia University in Montreal. Her scholarly writing has been published by the *Journal of Modern Craft online*, Telos Art Publishing, and *Surface Design Journal*, with forthcoming commissioned book chapters in: *The Handbook of Textile Culture* (Bloomsbury 2015); *Caught in the Act: An Anthology of Performance by Canadian Women, Volume II* (YYZ Press 2016); and *The Companion to Textile Culture* (Wiley-Blackwell 2016). Lisa Vinebaum is an Assistant Professor in the department of Fiber and Material Studies at the School of the Art Institute of Chicago, and the Associate Editor of *Textile: The Journal of Cloth and Culture*, published by Routledge/Taylor and Francis.

There are many people to thank for helping to see this publication to fruition, as well as those who have, over the years, supported the artwork found within. Thank you to Black Dog Publishing, especially João Mota for his beautiful design and dedication to the production of *Grafting Propriety*. I am very appreciative of the contributors: Emma Cocker, John Plowman and Lisa Vinebaum, for their thoughtful and provocative texts which help to point the reader towards intriguingly interwoven and connected concerns found within the artwork without nailing it down. Thank you to Lincolnshire County Council and the Collection and Usher Gallery, especially Ashley Gallant and Maggie Warren for allowing me access to such great historical works as well as their steadfast support of the *Stitch & Peacock* exhibition. It was this exhibition that propelled me to publish *Grafting Propriety*. To Ottis Sturmey for his unwavering hard work and commitment in the epic creation of *Nest*. To Gerard Williams for his loyal support, advice and frustratingly correct critiques throughout all the artworks and this publication. Finally, Finlay Williams Maier for whom I am always thankful for and to. And to my parents for always coming.

Image Credits

**David Rowan**
cover, pg 10, pg 17, pg 20, pg 26, pg 28, Pg 29, pg 49, pg 50, pg 51, pg 52, pg 53, pg 54, pg 58, pg 59, pg  61, pg 62, pg  64, pg 65, pg 67, pg 68, pg 69,pg 85, pg 87, pg 89,  bottom pg 116

**Andrew Weekes**
pg 18, pg 21, pg 22, pg 24, pg 25, pg  39, pg 40, pg 42, pg 43, pg 44, pg 45, pg 47, pg 48, pg 56,

**Gerard Williams**
pg 90, pg 91, pg 122, pg 123, pg 124, pg 125

Colophon

Designed by João Mota at Black Dog Publishing Limited.

Black Dog Publishing Limited
10a Acton Street, London WC1X 9NG
United Kingdom

Tel: +44(0)20 7713 5097
Fax: +44 (0)20 7713 8682
info@blackdogonline.com
www.blackdogonline.com

All opinions expressed within this publication are those of the authors and not
necessarily of the publisher.

British Library Cataloguing-in-Publication Data. A CIP record for this book is
available from the British Library.

ISBN: 978-1-910433-07-2

Black Dog Publishing Limited, London, UK, is an environmentally responsible
company. *Grafting Propriety: From Stitch to the Drawn Line* is printed on
sustainably sourced paper.

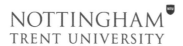

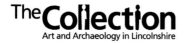
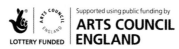